NORTH CORK

THROUGH TIME

Kieran McCarthy
& Daniel Breen

AMBERLEY

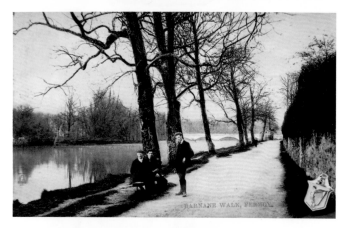

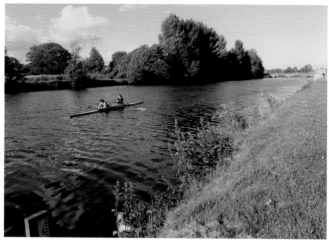

Dedicated to my good friend Sean Kelly and all those journeys
to gymkhanas in North Cork and along the Blackwater
to Ballyrafter Equestrian Centre (Kieran McCarthy).

First published 2015

Amberley Publishing
The Hill, Stroud, Gloucestershire, GL5 4EP
www.amberley-books.com

Copyright © Kieran McCarthy and Daniel Breen, 2015

The right of Kieran McCarthy and Daniel Breen to be
identified as the Author of this work has been asserted
in accordance with the Copyrights, Designs and Patents
Act 1988.

ISBN 978 1 4456 4774 6 (print)
ISBN 978 1 4456 4775 3 (ebook)

British Library Cataloguing in Publication Data.
A catalogue record for this book is available from the
British Library.

Typesetting by Amberley Publishing.
Printed in Great Britain.

Introduction
A Region of Nostalgia

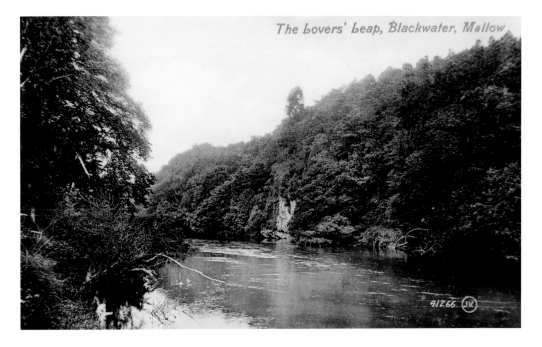

The Lovers' Leap, Blackwater, Mallow

Lovers' Leap, Fermoy
The River Blackwater sets a frame of romantic scenery for much of North Cork and its histories. Its tranquillity and flow have been a muse for photographers and writers for many centuries. It rises on the Cork/Kerry border and flows in its 169 km journey in County Cork through the towns of Mallow and Fermoy, then onto County Waterford through the towns of Ballyduf, Lismore and Cappoquin and finally enters the sea at Youghal, back in County Cork. The total catchment area of the River Blackwater is 3,324 km^2 and it is one of the best salmon fishing rivers in the country.

It is easy to get entangled in the multi-storied landscape of North Cork, and with next to no effort one can get lost in them and be inspired by them. This is a region with so many stories to tell, from veins of nostalgic gold drawn out of tales of conquest to subtle tales of survival. There are many roads to travel down and many historical spaces to admire. The vast scenery casts a hypnotic spell on the explorer. The region is defined by the meandering River Blackwater and its multiple tributaries and by the mountainous terrain to the north. It borders four counties, those of Kerry, Limerick, Tipperary and Waterford.

The postcards that are featured in this book, taken for the most part between 1900 and 1920 show the work of various photographers, who sought to capture the region and sell their work to a mass audience. Not every town or village was captured in a postcard. This book brings together many of the key sites of interest and serves as an introduction to the rich history of the region.

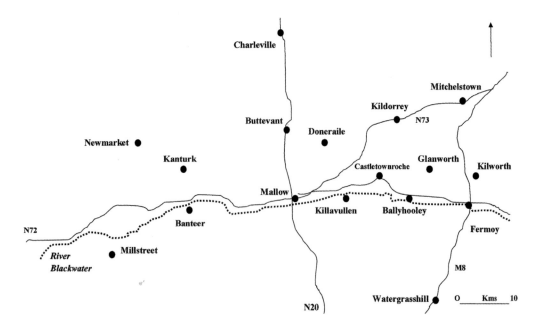

In the postcards, one can see the beauty that the photographers wished to share and express. The multitude of landmarks shown in this book have been passed from one generation to another. They have evolved in response to their environments and contribute to giving the county of Cork and its citizens a sense of identity and continuity. They represent the voices of people in the past and through the modern-day photos show the place and role of heritage in the modern day. Every landmark has its own scale and intrinsic detail or details which allow its meaning to be validated and recognised as important to a society's past within the present, or as a minor aspect of the present.

Cultural heritage does not end at monuments and collections of objects. It also includes traditions or living expressions inherited from our ancestors and passed on to our descendants. Pilgrimages and rituals are also engrained in many of the scenes within the postcards. Even mundane performances can construct a historic past and help weave personal and local memories with established national and regional historical narratives.

In many of the postcards, the scene is set up to elicit a response and to create a certain emotion within us, or because they make us feel as though we belong to something – a region, a country, a tradition, a way of life, a collective memory, a society. North Cork is blessed with such an array of diversity in heritage sites and there is a power in that diversity.

Chapter one explores the territory that borders County Kerry – a type of frontier territory for Cork people – its history epitomised in the elegant and well-built Kanturk Castle, the gorgeous town of Millstreet with its international equestrian centre and its access into the historical butter roads of the region, the use of secondary rivers for transport and industry, and the development of railways lines.

Chapter two centres around the Limerick Road from Mallow to Charleville – Mallow a settlement with a heritage dating back 800 years that straddles the winding River Blackwater. The town came into its own in the nineteenth century with the development of its main street,

churches, academies, convents, viaduct, clock tower and spa house, all interwoven with the commemoration of Ireland's famous writer and poet, Thomas Davis. The idea of an interwoven and multi-narrative heritage is also present in Buttevant. A former walled town, its medieval fabric is shown in its streetscape and old tower, Franciscan church and the ruinous Ballybeg Abbey in the town's suburbs. On the latter site its columbarium or pigeon house reminds the visitor of the importance of seeing the human side of our heritage – that people minded the birds and in a cherished way created the house with all its square roosts. Charleville also connects to an English colonial past being a late-seventeenth-century plantation town named after Charles II.

Chapter three glances at the area east of the Mallow–Limerick road, taking in the stunning Doneraile estate with the spacious streetscape of the nearby village. Killavullen, Castletownroche and Kilworth all present their industrial pasts. Along the Blackwater, Ballyhooley Castle stands in defiance of time, as does Moorepark and Glanworth Castles, just off the old Fermoy–Mitchelstown Road. The nineteenth-century estates boast numerous stone walls and old ruinous, rusted gateways. There are exceptions such as Castlehyde, which stands as a testament to the affection of the Flatley family, the current guardians of its heritage, but also a salute to the many families who inherited such estates and landscapes. Mitchelstown stands in the 'Golden Vale' of the Galtee Mountains, its heritage being linked back to the Kingston estate and their big house, which dominated the local landscape with views of all it surveyed.

Chapter four explores Fermoy, which because of its history and connection to a local military barracks, possesses a fine range of postcards. Its bridge and weir, views of the Blackwater, the nineteenth-century square, colourful streetscapes all reveal the passion held for such a place by its photographers. Still today, you can almost hear the hoof noises and creaking carriage wheels of the Anderson coach works and the marching of the military in the now disappeared army barracks. Above all Fermoy through its heritage exhibits a strong sense of place, a proud settlement, traits which pervade across North Cork and its landscape.

CHAPTER 1

Border Territory

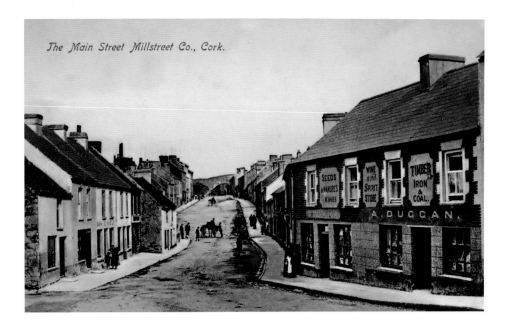

The Main Street Millstreet Co., Cork.

The Heart of Muskerry

The town of Millstreet is situated on the south side of the Blackwater, amid the lofty mountains of Muskerry. The town is directly connected by the first tourist project ever created in Ireland – the Cork–Killarney Turnpike road opened on 1 May 1748. This road was built by John Murphy of Castleisland who was the first to recognise the tourist potential of Killarney's lakes and Blarney Castle and created a road that joined them together. That road later thrived as one of the historic Butter Roads that led towards Cork City's butter market. Before the creation of the road, Millstreet consisted only of an inn, a mill and five small cabins. The Duggan family as shown in the postcard above today operate the well-known and international Green Glens Equestrian Arena complex.

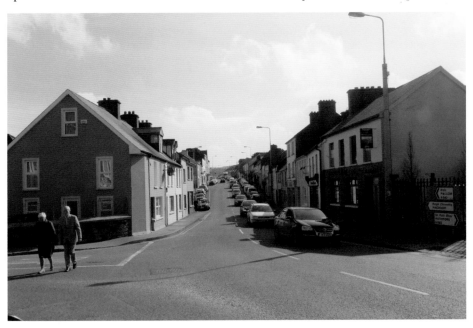

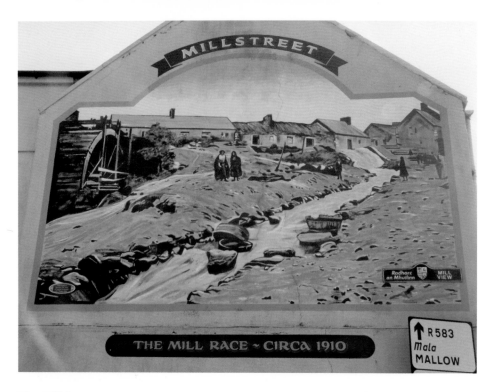

The Mill Race

In the nineteenth century, due to four extensive flour mills and an ale and porter brewery (est. 1835), Millstreet transformed into one long street, with several smaller ones diverging from it, and contained 312 houses. The mills inspired the name of the town. Fairs were held regularly for the sale of cattle, horses and pigs. In the heart of the town today is a War of Independence monument, which was officially launched in 1927. Among those commemorated at the monument is Captain Con Murphy who in 1921 became the first volunteer of Óglaigh na hÉireann to die before a firing squad since the 1916 Dublin executions.

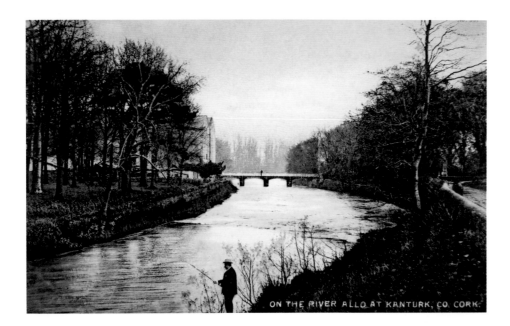

ON THE RIVER ALLO AT KANTURK, CO. CORK.

MacCarthy's Mansion

In the thirteenth century, the MacCarthys emerged as the most powerful Gaelic clan as they resisted the Anglo-Norman expansion into the south-west of Ireland. The MacCarthys secured control of South Kerry and the western half of Cork. A subsept of the MacCarthy Mór clan, MacDonagh MacCarthy established the lordship of Duhallow. In the early seventeenth century MacDonogh Carthy commenced the erection of an extensive castellated mansion, which was to become known as Kanturk Castle. In time a small settlement, Kanturk village (derived from the Irish Ceann Tuirc or Boer's Head), developed nearby, which straddled the Rivers Allo and Dalua. Over the Allua an elegant stone bridge of six segmental arches was constructed in 1745 while over the Dalua, a bridge of five arches was built in 1760.

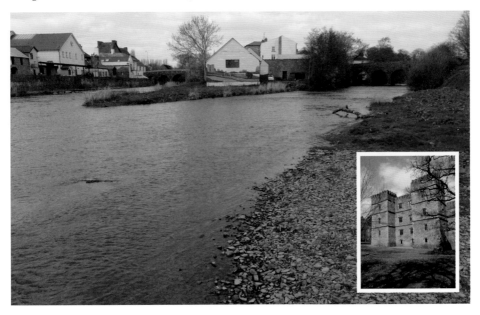

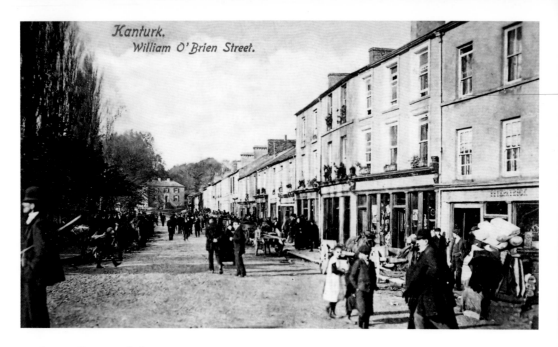

Kanturk. William O'Brien Street.

At the Confluence of Rivers

In the 1840s, improvements to the streetscape of Kanturk town were pursued under the auspices of the Earl of Egmont (the proprietor of the greater part of the town since 1641). The settlement was irregularly built, consisting of several short streets chiefly diverging from the centre. In the immediate vicinity, on the river Dalua, were the extensive boulting-mills of Dr Barry, a portion of the produce of which, and of another on a smaller scale mill near the castle, was sent to Cork, where it was shipped for England. The former of these mills was capable of manufacturing 12,000 bags of flour annually.

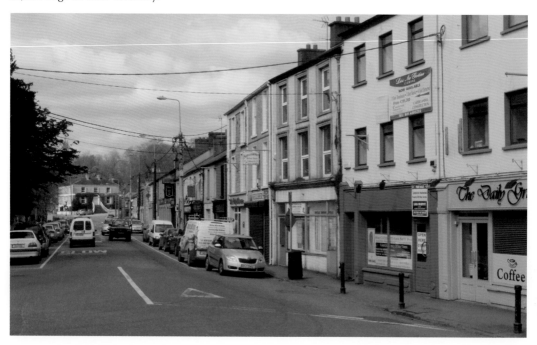

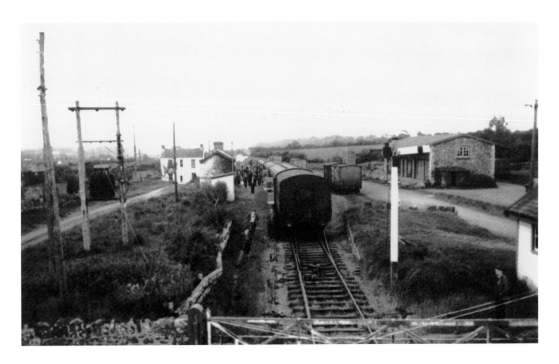

A Railroad of Heritage

The first section of the Mallow–Killarney line was constructed in 1853 with the intention of tapping the tourist potential of Killarney, as much a tourist attraction then as it is today. At the Banteer station, there is a siding on the up side at the Mallow end of the station. This served as a loading bank, on which was a goods store, both since demolished. There was previously a line behind the up platform. This was used by Newmarket branch line trains. This branch closed in 1963.

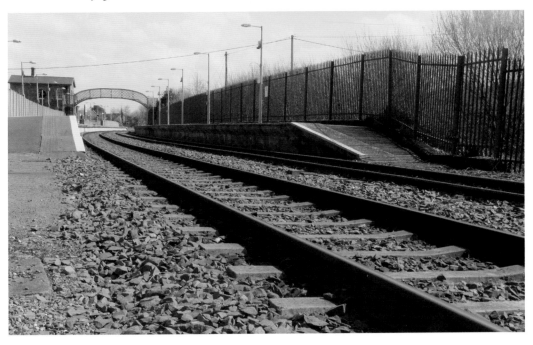

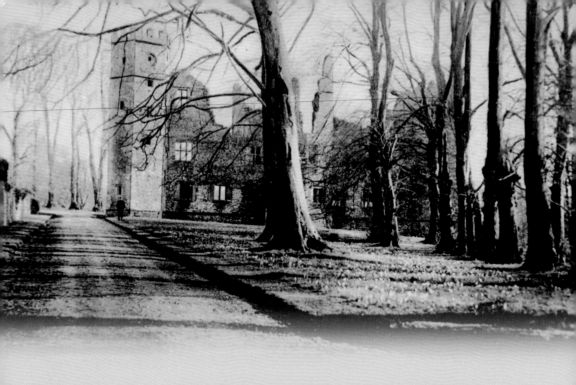

CHAPTER 2

The Limerick Road

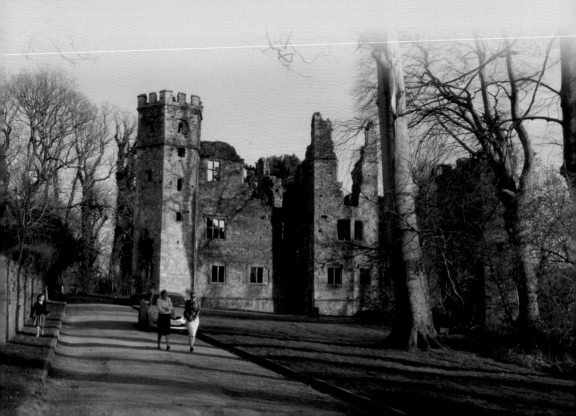

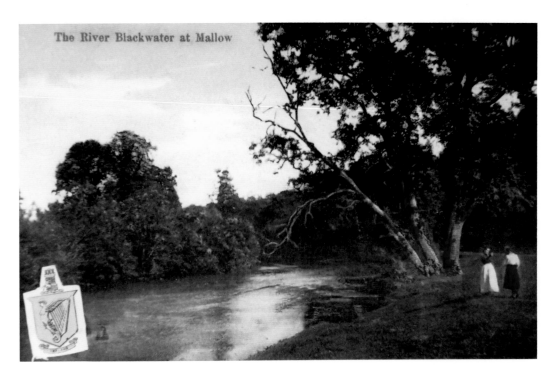

The River Blackwater at Mallow

The Plain of the Swans

The historic town of Mallow was initially developed as a defensive settlement protecting an important ford on the River Blackwater. The name Mallow derives from the Irish *maghalla*, translated as 'plain of the swans'. The town developed rapidly in the late sixteenth century as an English plantation town. In the eighteenth and nineteenth centuries Mallow became famous as a spa resort and became known as 'The Irish Bath'. Throughout the centuries the town has prospered as a market town, helped by the River Blackwater, its rich agricultural hinterland, its central location and its importance on the railway network.

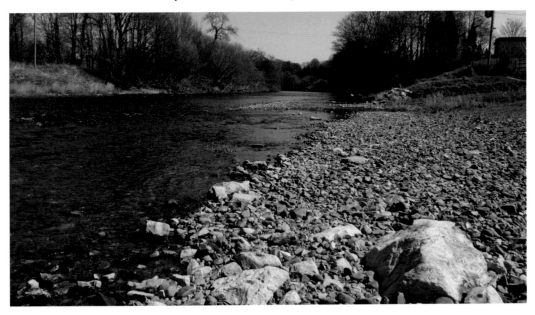

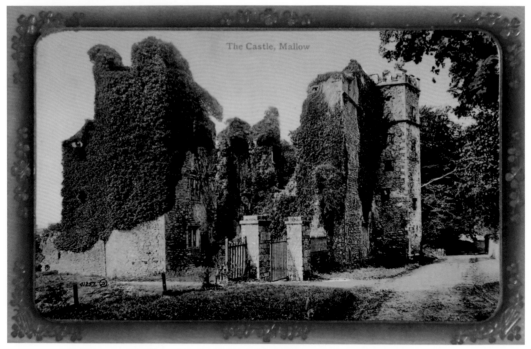

The Castle, Mallow

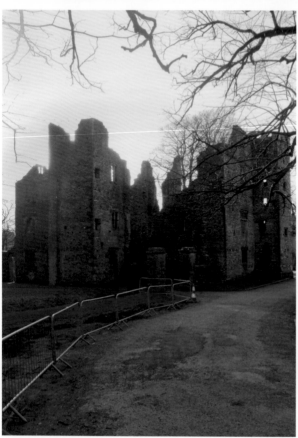

A National Monument

The original Mallow Castle was built by the Normans in 1185, after the native O'Keeffe's had been dispossessed. In 1282, the Desmond Fitzgeralds built a new castle. Soon afterwards, a Baron of the Geraldines, Thomas Fitzmaurice, traded his land in Kerrylocknaun, Connaught, with the Desmond Fitzgeralds. After Thomas Fitzmaurice died in 1298, the land stayed in Geraldine hands until the rebellion in the closing stages of the sixteenth century, when the Earl of Desmond's brother, Sir John of Desmond, took possession of it. However, he and his wife, Ellen, had no children, so the castle was not inherited and left to rot. It then passed through a stream of owners, including Sir William Pelham and Sir John Norreys of Rycote in Oxfordshire. His brother, Sir Thomas Norreys, inherited the 6,000-acre estate in 1596. In 1928, the building was made an Irish Free State national monument.

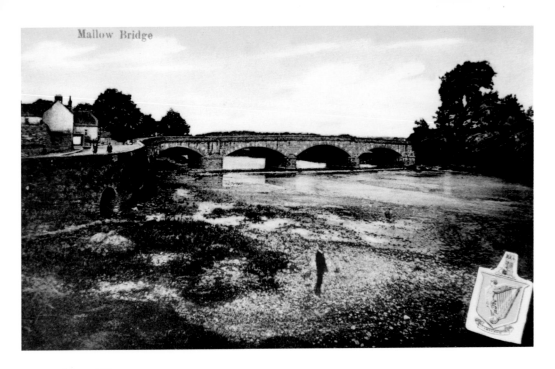

Mallow Bridge

Bridge of Time

The section of four small arches on the town side of Mallow Bridge is all that remains of the first stone bridge over the River Blackwater. Built in 1712, it had a total of fifteen arches. During the severe flood of 1853 several of the arches were swept away and others were severely damaged. This section was replaced by a new bridge of four arches in 1856. On the bridge stands a monument to the volunteers of the old Irish Republican Army of the Mallow area who gave their lives in the War of Independence.

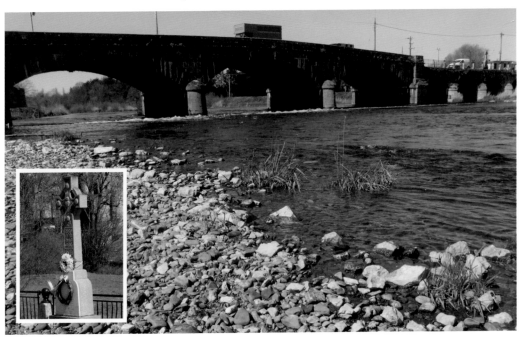

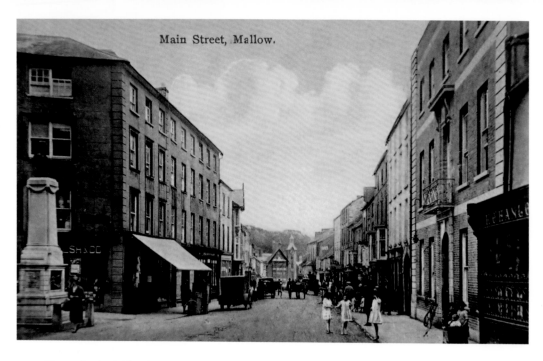

Main Street, Mallow.

By an Ancient Charter

In 1612, Mallow town received its first charter of incorporation from James I. By that charter the corporation consisted of a provost, twelve burgesses, and a commonalty. The charter also conferred the privilege of returning two members to the Irish parliament. The statue of John Joseph Fitzgerald on the main street, and seen on the left of the postcard and inset below, recalls his work with the Irish Land and Labour Association. This group attempted to organise tenant farmers and agricultural labourers. He also played an active role in establishing an urban district council in the town.

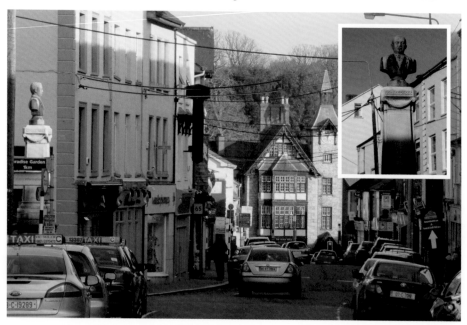

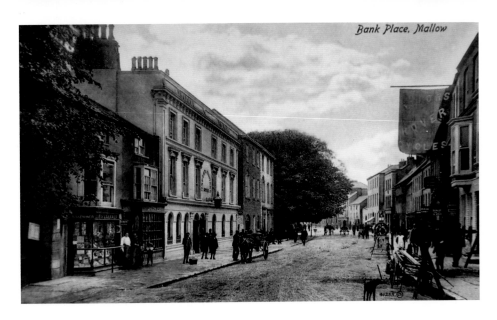

Bank Place, Mallow

Banking on Success

The postcard shows a busy street scene. Delving deeper and using a County Cork Street Directory from 1915, the list of businesses on Bank Place included Thomas Homan's Surgery, Mr Dixon's Chemist shop, Mr Davin's Auctioneers, Thomas Quinn's Boot and Shoe Warehouse, Mr Priestly's Brewer's Agents, Mr Sherman's Builders, Miss Flynn's dressmaker business, Miss Boland's Fruiterers, Miss Hannan's Grocers, Mr Weedle's Jewellers, the lodging houses of Mrs Donoghue, Mrs Lindsay and Mrs Roche, Mrs Power's provision dealer, Joseph Harold's stationers, the vintners of Ms Hannon and Ms Linehan, and Mr T. W. Priestley's wool merchants. Today the street is still a busy place and is currently undergoing regeneration.

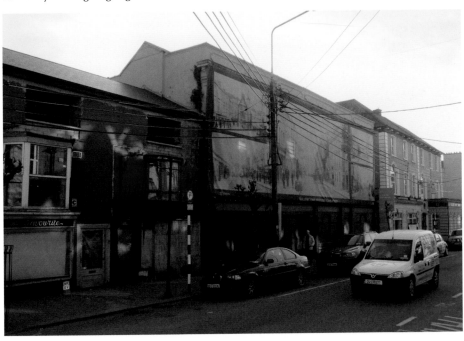

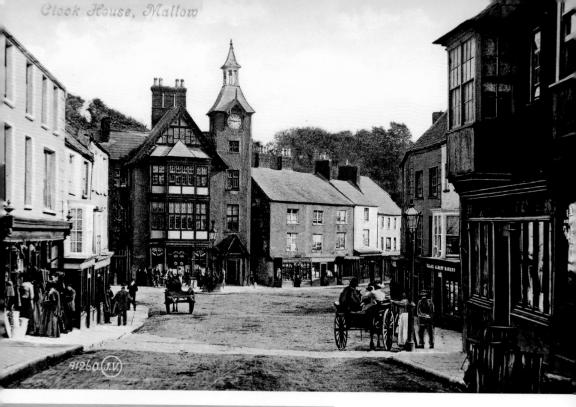

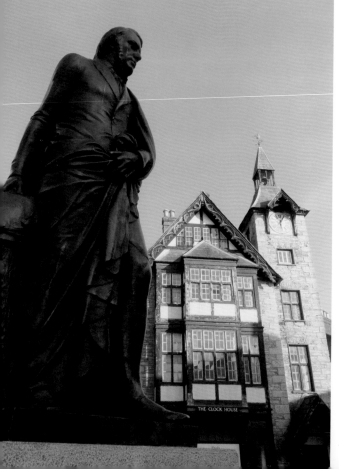

THE CLOCK HOUSE

For All Time

Situated in the heart of Mallow town centre and overlooking Main Street to the north, is one of the town's most recognisable landmarks – the clock tower. The half-timbered Tudor-style façade fills the building with character. It was built around 1855 using the designs of a local amateur architect, Sir Denham Orlando Jephson. The building was once a licensed premises. The bell tower became structurally unsound and was removed around 1970 for safety reasons. The building has been used as offices for many years and the owners have recently invested a considerable sum in works to bring the internal of the building to a high standard. Adjacent today stands the Thomas Davis statue in remembrance of an eminent Irish statesman, writer, and one of the instigator of the Young Ireland Nationalist movement.

Emancipation and Tolerance

Charles Denham Jephson-Norreys donated a site south of Main Street, Mallow for the construction of St Mary's Roman Catholic church. Here in 1818 the church of St Mary was built. This was a triumph in an intolerant time when the struggle for emancipation was still eleven years from victory. Fr Thomas Barry, the parish priest of the time, led his congregation from their old mass-house in Chapel Lane to the new imposing structure. The church was originally built behind a row of houses that stood along Main Street Access was by a narrow lane to the west and south of the present Credit Union building, formerly the National Bank. It was unacceptable in the days before Catholic Emancipation in 1829 to have a Catholic chapel in a prominent position. These houses were gradually removed, thus providing a piazza fronting on to Bank Place.

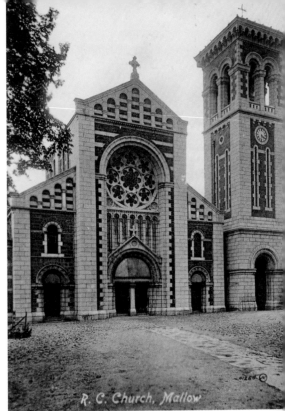

R. C. Church, Mallow

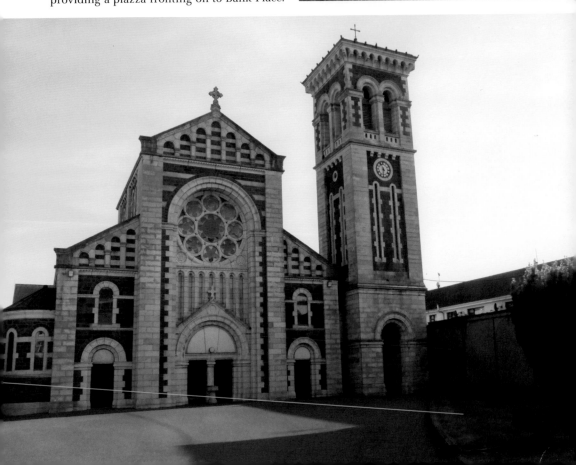

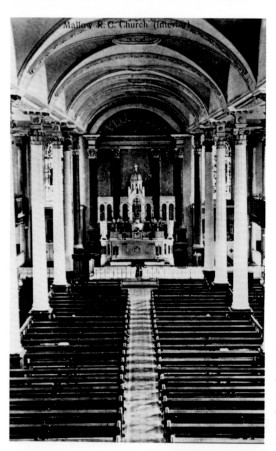

Mallow R. C. Church (Interior)

Interior Beauties

The new St Mary's church was cruciform in plan including a basic nave with side aisles and shallow transepts with galleries. Initially it had an earthen floor and no seats. During the first two decades of the twentieth century, Canon Wigmore (1881–1917) had the church enlarged and some of it rebuilt. He employed the services of Messrs Ashlin and Coleman architects to carry out this work. The interior was also embellished with a beautiful rib vaulted plaster ceiling and fluted columns this was the work of the Orangie family from Italy. In the 1990s the roof was found to be unsafe and it was completely reroofed. Unfortunately, the ceiling executed by the Orangie family earlier in the century was unable to be saved. The ribbed vaulted portion over the nave was replaced by a plain tunnel vault.

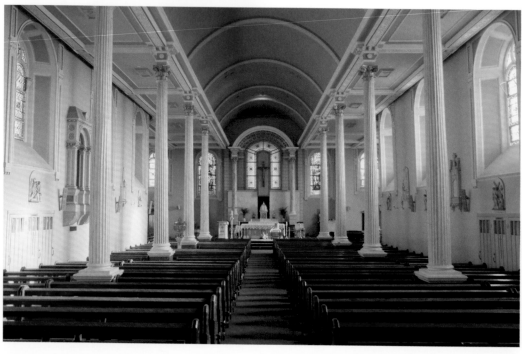

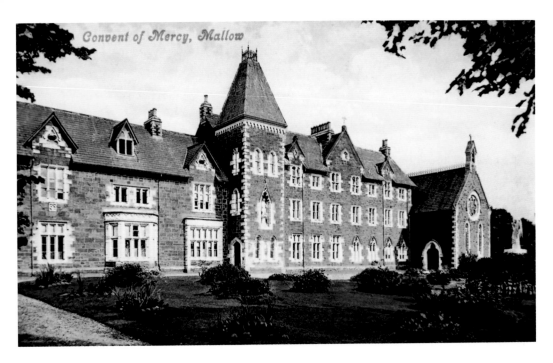
Convent of Mercy, Mallow

Signs of Mercy

In 1845, at the request of Mallow Parish priest Father Collins, seven Mercy nuns arrived from the Mercy Convent in Limerick to administer and help the people of the town in their distress during the dark days of the Famine. They lived in a rented house beside St Mary's church where the Credit Union now stands. In 1850 the Sisters moved to their present convent at Bathview. The two-storey building accommodated juniors on the ground floor and seniors up to eighth class upstairs.

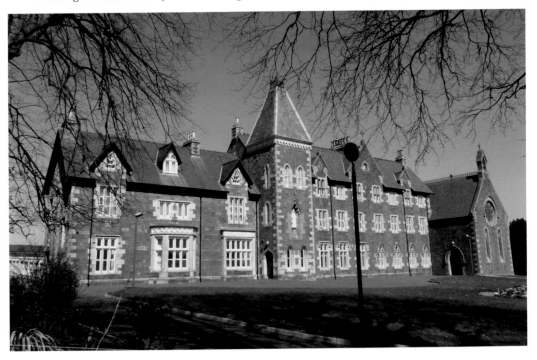

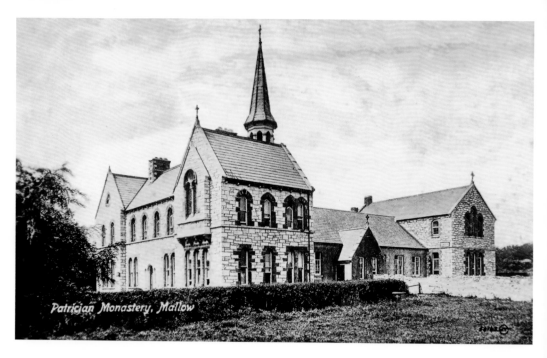

Patrician Monastery, Mallow

The Patrician Academy

The school was established by the Catholic diocese of Cloyne over 130 years ago with the purpose of providing education for the young boys of Mallow. For most of its lifetime the school was managed by the Patrician Brothers who left Mallow in 1994. The school is now managed by a Board of Management consisting of four trustee representatives, two parents' representatives and two teachers' representatives.

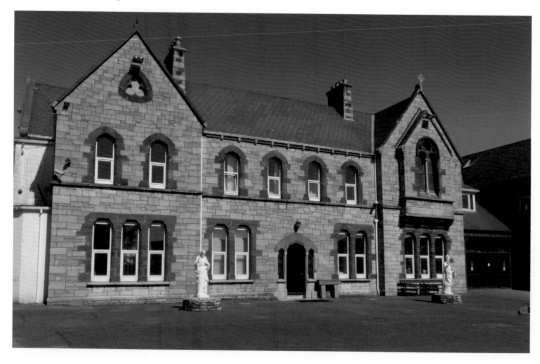

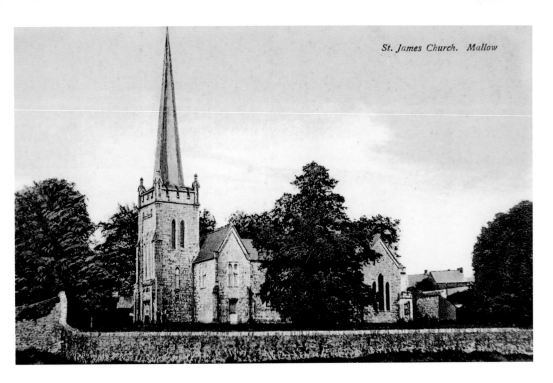

St. James Church. Mallow

Pains' Soaring Heritage

This church of Ireland is a Gothic-style building though with a very distinctive 'H' shape, with a tower and steeple at one end and a large chancel at the other. It is built mainly in limestone, a local stone. It was originally built in the 1820s to accommodate 800 people but, with the removal of the side galleries it will now hold about 350. The builders were James and George Richard Pain, architects, operating in Cork and Limerick.

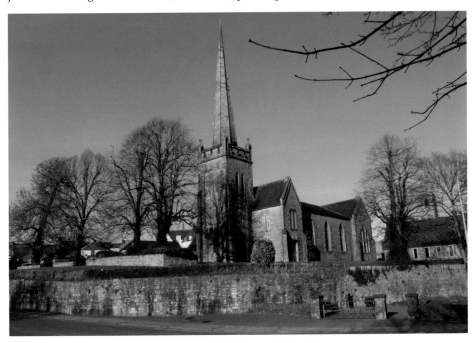

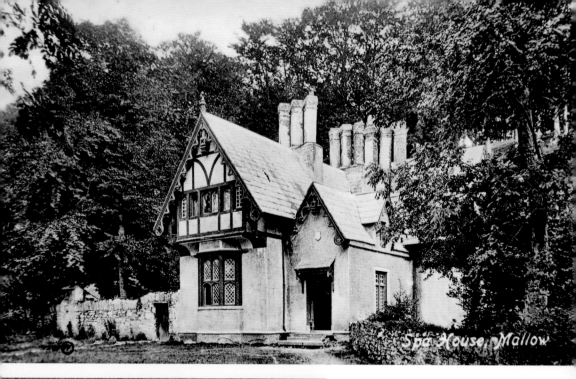

Spa House, Mallow

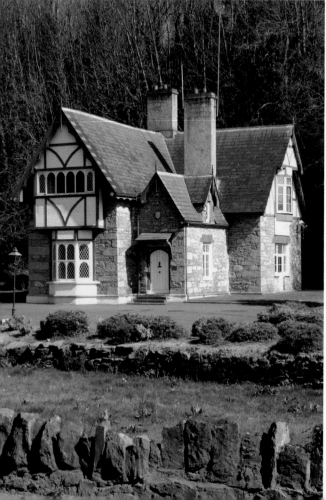

Relaxing at the Spa House

The spa house was built in 1828, by C. D. O. Jephson, MP. It is in the old English style of rural architecture, and in its day contained a small pump-room, an apartment for medical consultation, a reading-room and baths. The building was fitted up for supplying at short notice, hot and cold salt-water, vapour, and medicated baths. The approach to the spa from the town is partly through an avenue of lofty trees along the bank of an artificial canal, affording great scenery.

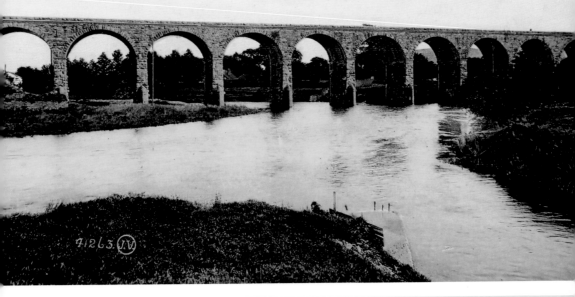

71263. J.V

The Ten-Arched Bridge

The bridge at Mallow carried the Great Southern and Western Railway main line over the River Blackwater. The bridge was originally constructed in 1848–49 with ten masonry arches each of 60-feet span and came into service in October 1849. The engineer was Sir John MacNeill and the contractor was William Dargan. On 9 August 1922 during the Irish Civil War, that followed the Anglo-Irish Treaty of December 1921, explosives destroyed the arches. The designers for the replacement bridge were J. F. Crowley & Partners of Dublin and London and the present steel superstructure was decided upon.

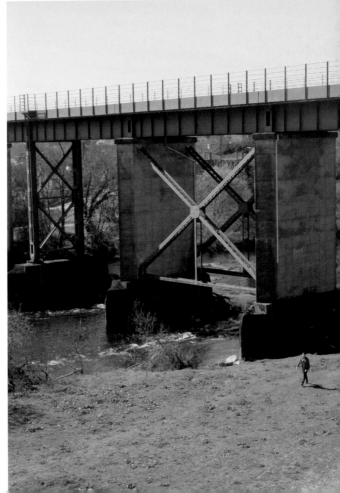

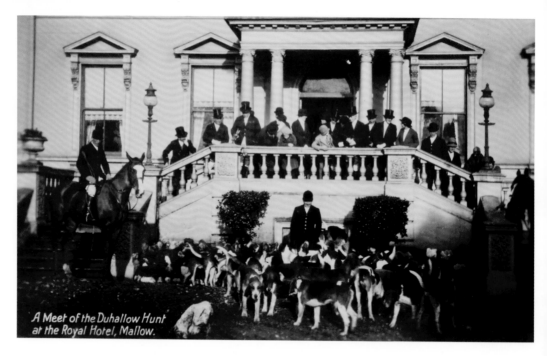

A Meet of the Duhallow Hunt at the Royal Hotel, Mallow.

Hunts and Hotels

The world of hunting and point-to-points has a proud history going back many years, and no area possesses a stronger tradition than the Duhallow hunt in County Cork. The Duhallow foxhounds hunt a large area in the rebel county, stretching from Charleville in the north to Blarney in the south, and Fermoy in the east to the Kerry border westwards. The hunt is still thriving today with 200 members young and old, and numbers on a day's hunting have to be restricted to between fifty and sixty. The old Royal Hotel is now the offices of Cork County Council in the area.

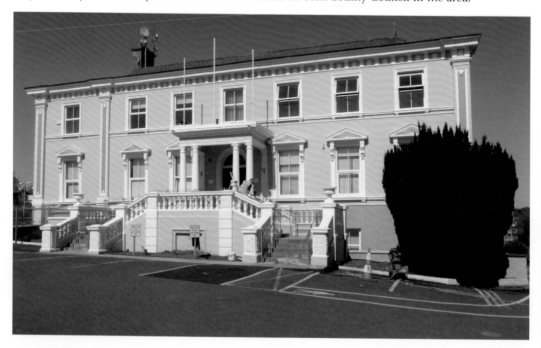

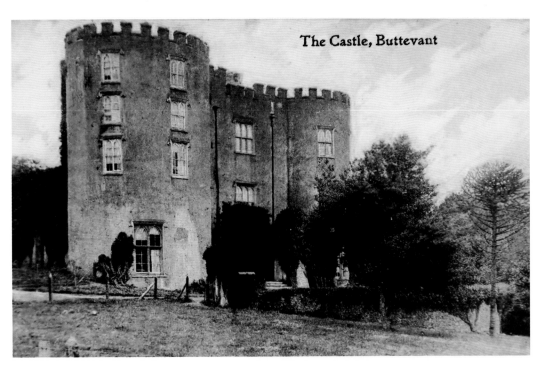

The Castle, Buttevant

The de Barry Legacy

Prior to the arrival of the Normans in the twelfth century, Buttevant was known as Kilnamullagh, 'the church on the hillocks'. The name Buttevant comes from the French term for castle fortress or *boutevante*. In 1177 Robert FitzStephen, a Norman-Welsh baron, was granted the eastern half of the kingdom of Cork by Henry II. FitzStephen along with his nephew Philip de Barry and Raymond de Gros had previously conquered the lands of the Donegan clan in North Cork known as Muscraí Donegan. De Barry was to inherit Muscraí Donegan and the Lehan lands in Castlelyons from his uncle in 1180. It was he and other members of the de Barry family that were to have the greatest impact upon the town, creating the medieval legacy that exists today in the town.

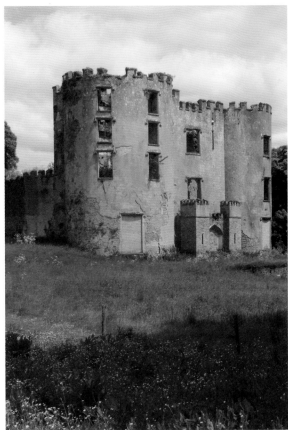

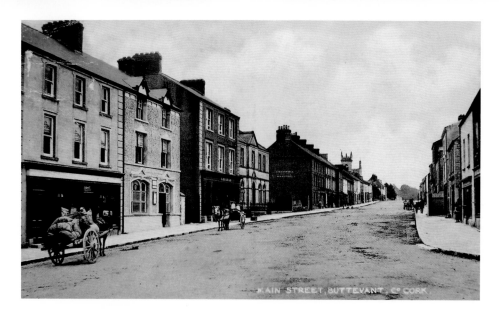

Buttevant as Bastide

The de Barrys planned their town as a Bastide, similar to the Norman towns of south-western France, Normandy and southern England. It was laid out in a very specific grid pattern with the Market House/Green as well as Lombard's Castle, orchard and garden occupying precise square sites. By 1229 both the de Barry castle and Augustine Abbey at Ballybeg had been completed. Later on that century the de Barrys installed the Franciscans in the town, building them a friary. It was also around this time that the limestone bridge that still spans the Awbeg River was built. In 1317 a grant of £105 was received to surround the town with walls.

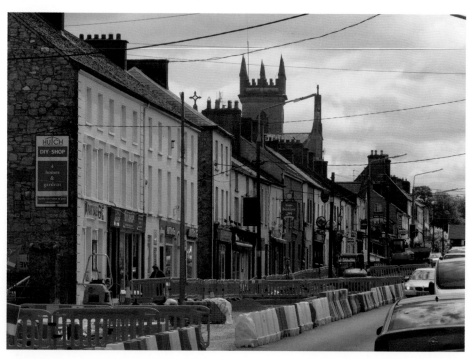

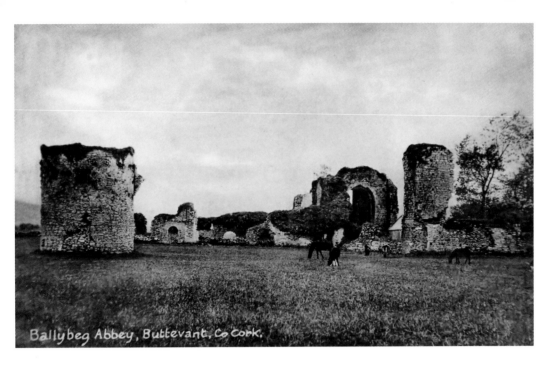

Ballybeg Abbey, Buttevant. Co Cork.

Niches of Memory

In 1229 Philip de Barry endowed the priory of Ballybeg for regular canons following the rule of St Augustine and in remembrance of his endowment his equestrian statue in brass was erected in the church. Visitors can view remains of the church, three-storey tower and stone coffins. The site has one of the finest surviving medieval dovecots in Ireland (building on the left of postcard and picture). This was used to keep pigeons, which ate waste grains from the priory's farm, and which themselves then provided an important source of protein for the canons. The rows of stone niches were for nesting while the hole in the corbelled rood allowed in and out.

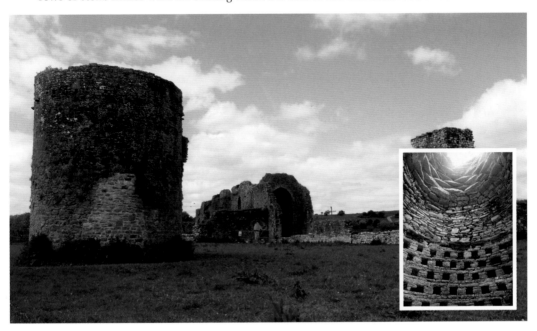

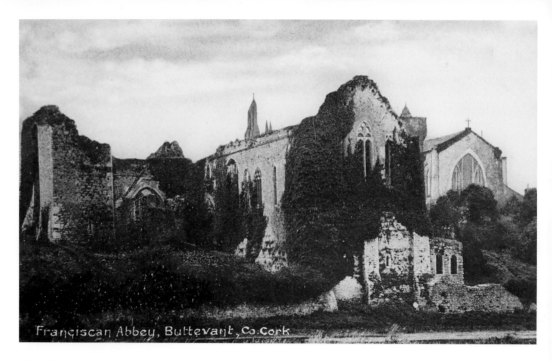

Franciscan Abbey, Buttevant, Co.Cork

The Edges of History

Overlooking the Awbeg River, the thirteenth-century Franciscan site in Buttevant was founded by David Oge Barry and dedicated to Thomas Becket. After the abbey was dissolved, it was taken over by the Barrys. Still, the friars returned in 1609 and remained intermittently until 1783. Among the remains of the settlement, visitors will find a nave-and-choir church, several lancet windows, tomb niches, a double crypt and single piscine.

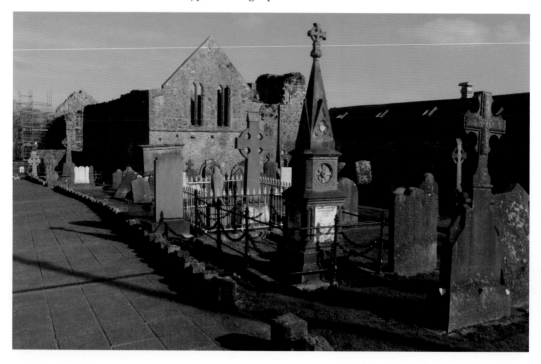

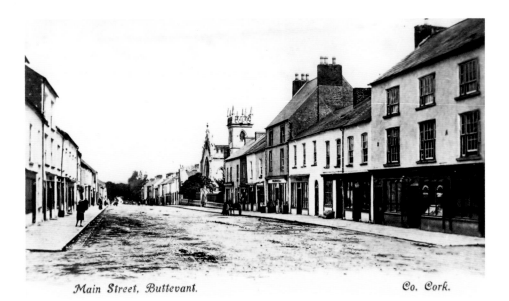

Main Street, Buttevant. *Co. Cork.*

From Steeple to Steeple

The main routeway in Buttevant extends along the old mail coach road, and in 1831 contained 204 houses. Near Buttevant Castle was an extensive and substantial flour-mill, erected by Sir James Anderson and furnished with contemporary machinery. It manufactured 20,000 barrels of flour annually. In 1752 the town was the starting point of the world's first steeplechase. Mr Blake challenged his neighbour Mr O'Callaghan, to race across country from Buttevant church to Doneraile church some four and a half miles distance and to jump stone walls, ditches and hedges. Buttevant is also famous for the Cahirmee horse fair, which is held each July. Two famous horses are reputed to have been bought at Cahirmee Fair: Napoleon's horse, Marengo, in 1799 and Wellington's charger, Copenhagen, around 1810.

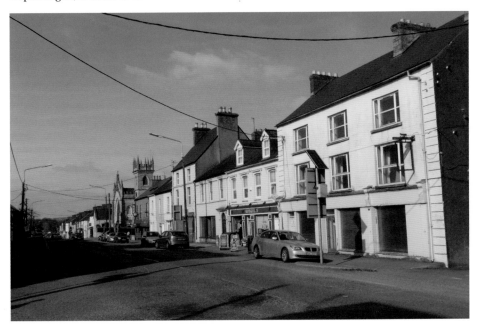

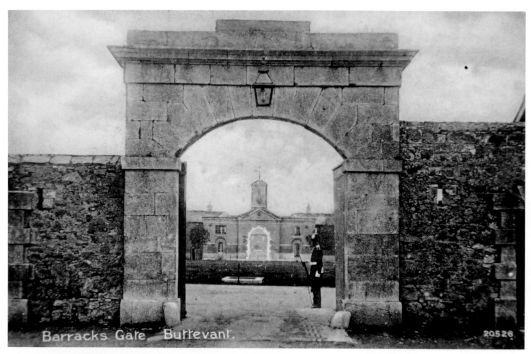

Barracks Gate, Buttevant.

20526

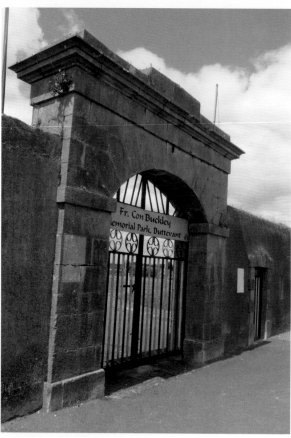

Fr. Con Buckley Memorial Park, Buttevant

A Gate of the Past

Despite being a walled town, Buttevant was frequently attacked and burned by the O'Briens of Thormond, as well as the McCarthys and O'Callaghans of Dunhallow. The town suffered heavily during the War of the Roses, Williamite War and Desmond Rebellion. Though the de Barrys became viscounts and earls, they eventually became absentee landlords, the last Earl of Richmond dying without issue. At the end of the eighteenth century the de Barry estate was sold to John Anderson, who altered the castle, built the mill, the military barracks and the current road between Mallow and Charleville. By 1830 he had sold the town and castle to Lord Doneraile.

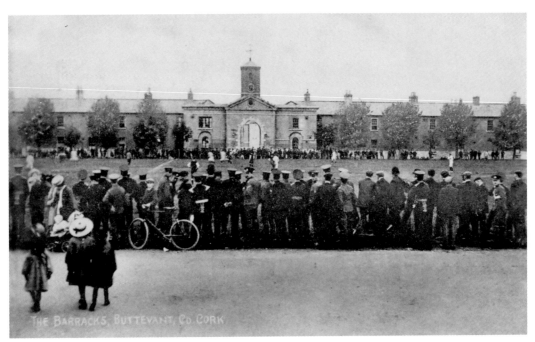

A Military Past

In the nineteenth century County Cork was part of the Southern Military District. There were sixteen military stations providing, in total, accommodation for 352 officers and 6,799 men. The barracks were for the most part populated by regular army regiments (the majority of whom were English) which were changed often. During the Victorian period 20,000–30,000 regular soldiers were deployed in Ireland at any one time for the 'maintenance of civil order'. Immediately adjoining, on the north-west of Buttevant town were the old barracks, an extensive range of buildings occupying a spacious enclosed area of nearly 23 statute acres. It was divided into two quadrangles by the central range, in which was an archway surmounted by a cupola and affording communication between them. O'Brien Terrace is all that remains of the ranges of buildings.

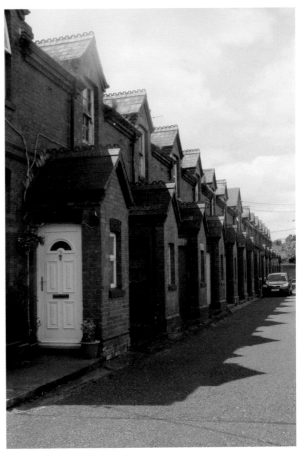

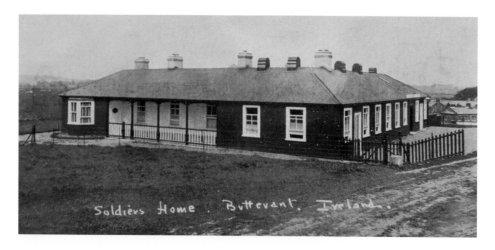

Soldiers Home : Buttevant. Ireland.

Soldiers and Duty

A hundred years ago, some of the men of Buttevant army barracks were sent to the front in the First World War. In December 1915 they were sent to France, in June 1916 to Loos, September 1916 to Guillemont and Ginchy, in November 1916, proceeded to Divisional Reserve at Curragh Camp Ireland and in November 1916 were absorbed by 1st Battalion RMF. During the war over two thousand Corkmen were killed. Many of them lie buried with hundreds of thousands of other British soldiers in the cemeteries of northern France and Flanders. The British Army left the Buttevant Barracks in 1922 after the Irish War of Independence and the buildings were then destroyed.

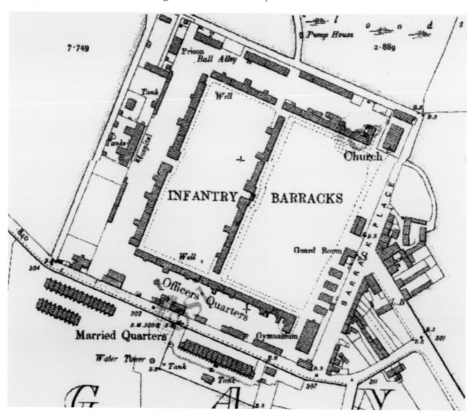

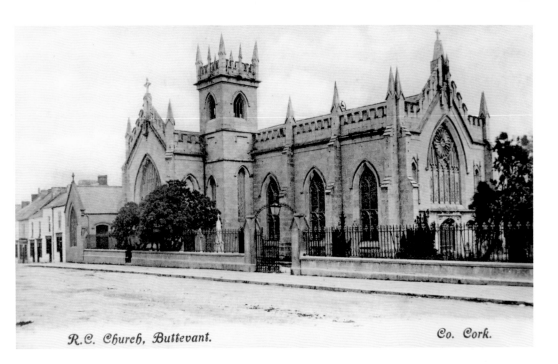

R.C. Church, Buttevant.　　　Co. Cork.

An Ornate Heritage

Catholic Emancipation was gained in 1829. Two years later the foundation was laid of the St Mary's parish church of Buttevant. Lord Doneraile donated the site. He with the Earl of Egmont, Lord Bandon, and many other non-Catholics, gave generous donations to the cost of building. The church was designed by architect Charles Cotterel of Cork in the perpendicular Gothic style. The building of St Mary's took five years to complete in fine local limestone. The north window is a most striking feature and is Munich glass designed and supplied by Mr Meyer of London.

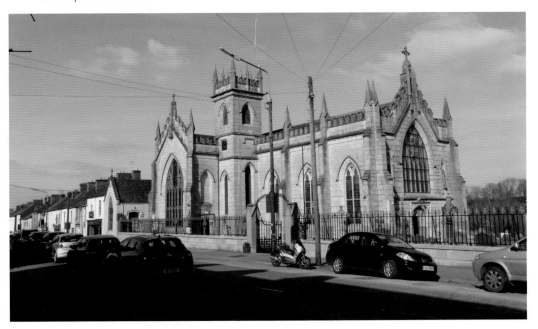

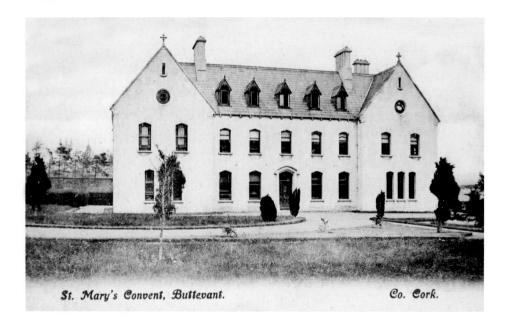

St. Mary's Convent, Buttevant. Co. Cork.

Works of Mercy

The detached two-storey St Mary's Convent, was built in 1879, comprising five-bay central block flanked by advanced gable-fronted two-bay ends and having six-bay side elevations. Designed by George Ashlin, this imposing building is at the centre of an ecclesiastical complex in the centre of Buttevant. The Tudor detailing in the windows, and Gothic detailing to the doors and to the dormer bargeboards are a characteristic theme of nineteenth-century ecclesiastical buildings. It is enhanced by its setting in landscaped grounds. The Sisters of Mercy arrived from Charleville to Buttevant in 1879 and had a 133-year association with the town heading up many works of mercy, including the formation of local schools.

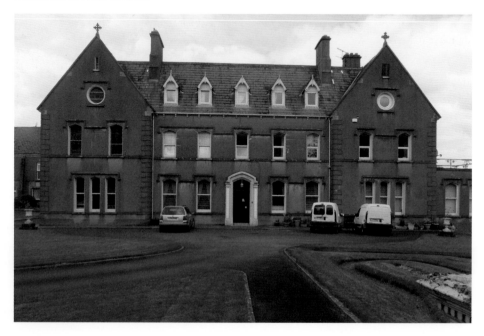

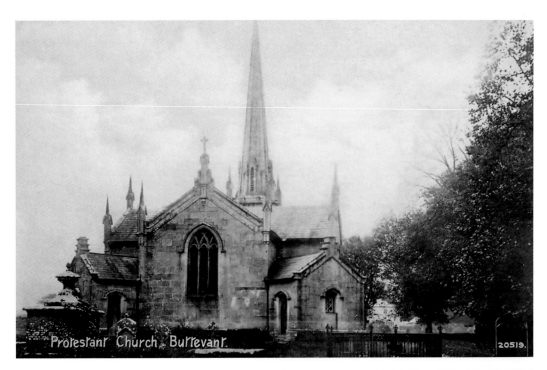

Protestant Church, Buttevant. 20519.

Pinnacles of Success

St John's church of Ireland is
situated in a very scenic spot just
off the main road at the southern
end of Buttevant's main street,
on the banks of the Awbeg River,
quite close to Buttevant Castle. The
church is a handsome structure in
the later English style with a square
embattled tower, surmounted by
a finely proportioned spire. It is
situated near the river and within
the old Castle Demesne, and was
built in 1826 near the site of the
ancient church of which there are
still some remains. In the cemetery
are the remains of two older
churches, one dedicated to St Brigid
and the other to the Virgin Mary.

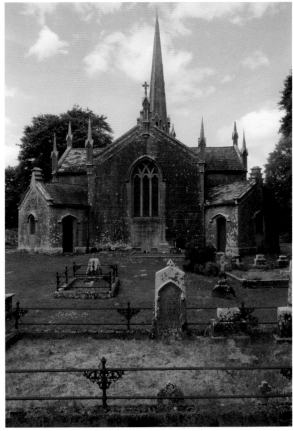

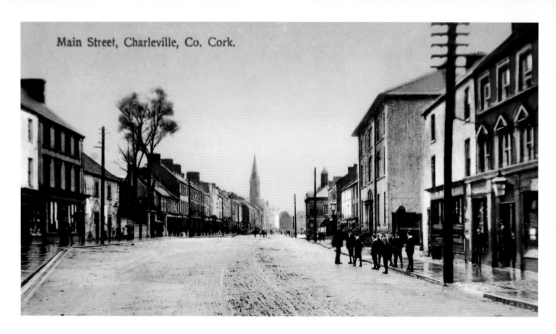

Main Street, Charleville, Co. Cork.

In the Name of Charles

Charleville is so named in honour of Charles II. It was founded by Roger, 1st Earl of Orrery and lord-president of Munster, in 1661. That nobleman erected a magnificent mansion here for his own residence, in which he kept his court of presidency. By his influence he obtained for the inhabitants a charter of incorporation from Charles II in 1671. Charleville House was burnt by the Irish under the command of the Duke of Berwick, in 1690, and by his order, after he had dined in it. The town consists principally of two parallel streets communicating by two others crossing them at right angles; one of which is a wide and spacious thoroughfare.

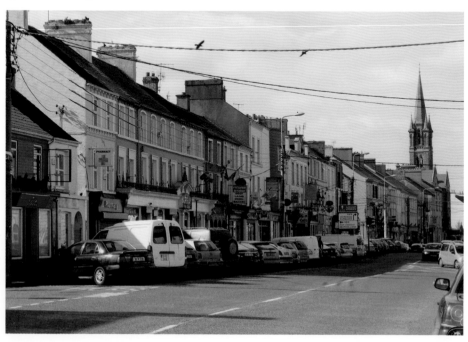

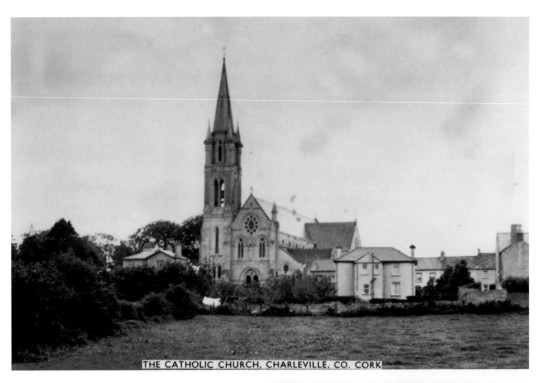

THE CATHOLIC CHURCH, CHARLEVILLE, CO. CORK

Eye-catching Design

This Gothic Revival church of Holy Cross, Charleville was erected to a design by Maurice Alphonsus Hennessy (1848/49–1909) of Cork and Limerick. The eminent George Coppinger Ashlin (1837–1921) had been invited to submit a design, but declined, while drawings in the Royal Hibernian Academy show the unexecuted proposal by Walter Glynn Doolin (1850–1902) of Dublin. Begun in 1898, the church was dedicated in 1902 although the eye-catching steeple was completed only in 1908/09.

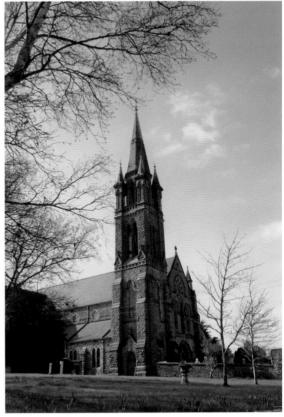

39

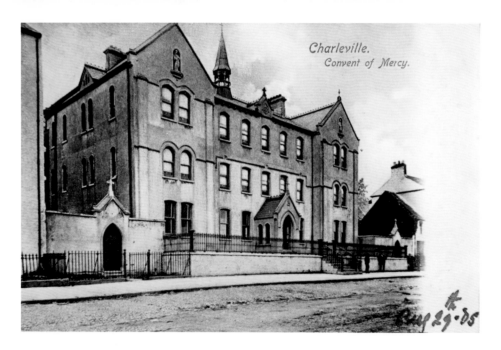

Charleville.
Convent of Mercy.

McAuley's Interventions

In pre-famine times, Charleville, like so many towns in Ireland had a very large population, but there was great poverty among the people. One of the ways of improving life in the area was to bring a religious order to the town. The bishop of the diocese of Cloyne, Dr Crotty, made a formal request of Catherine McAuley to send some of her sisters. She agreed to establish a foundation or Convent of Mercy in Charleville. On 29 October 1836 Catherine McAuley arrived in Charleville with Sisters Angela Dunne, Joseph Delaney and Elizabeth Hynes. About a year later, the foundation stone of a new convent was laid and the convent itself was opened in 1839.

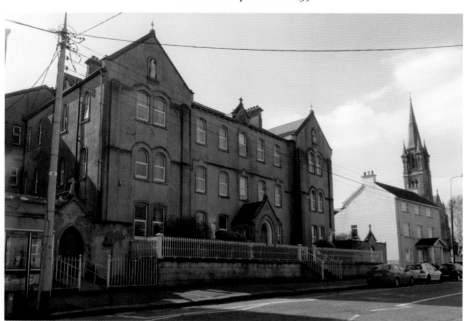

The Architecture of Literature

Charleville Library is located now in this former edifice St Thomas' Church of Ireland, which was built around 1846. The library consists of a ground floor and mezzanine level, with lift access. The original church ceiling was retained. The church was donated by the Church of Ireland for use as library in 1973.

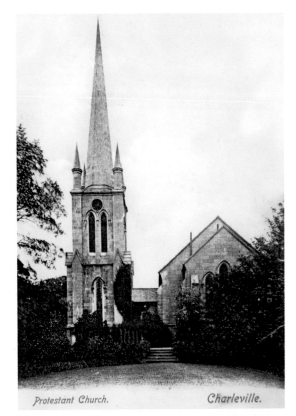

Protestant Church.　　　　Charleville.

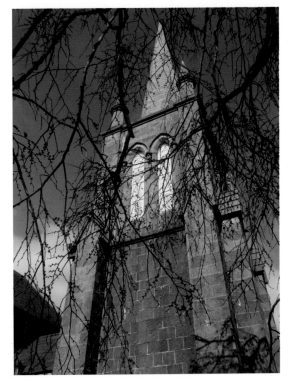

CHAPTER 3

East of Mallow

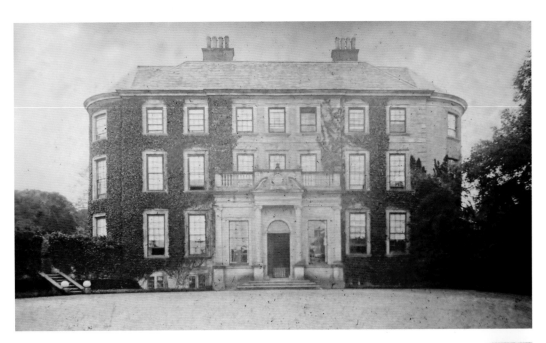

Doneraile Court

The St Legers were a Norman
family who accompanied William
the Conqueror to England, and
settled in Kent. Sir Anthony
St Leger was sent to Ireland in
1537 by Henry VIII to oversee the
dissolution of the monasteries,
and in 1540 succeeded Lord
Leonard Grey as Lord Deputy
of Ireland. The original house is
reputedly on the site of Doneraile
Court and was the home of some
of the St Legers from the 1690s
at least, and that 1725 is a date
of major renovation. The park,
now open to the public, comprises
approximately 166 hectares
and is an outstanding example
of an eighteenth-century
landscaped park.

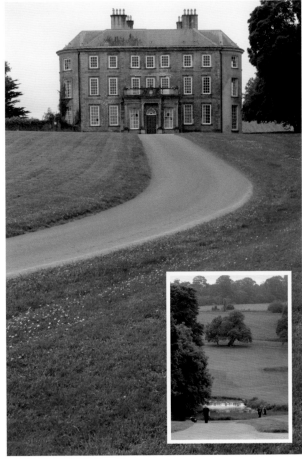

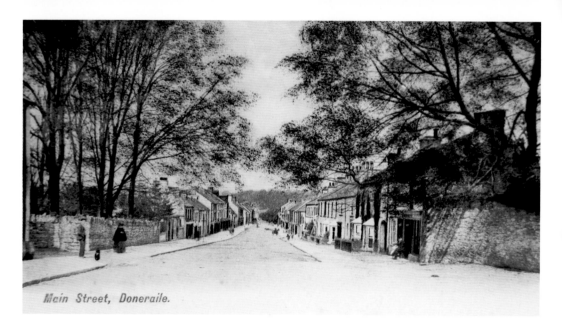

Main Street, Doneraile.

Doneraile Main Street

The village of Doneraile was attached to Doneraile Court. A charter of Charles I in 1639 constituted Sir William St Leger lord of the manor. At one time near the bridge was the extensive flour-mill of Messrs Creagh & Stawell. Doneraile is best known for its literary associations – Canon Patrick Sheehan, Edmund Spenser, William Makepeace Thackeray. Col James Grove White of nearby Kilbyrne wrote an important and expansive four-volume record of the topography and history of the North Cork area in the early twentieth century.

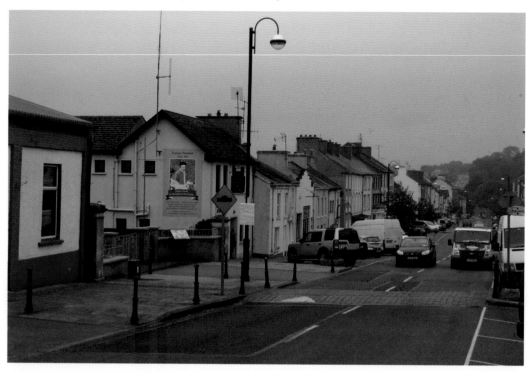

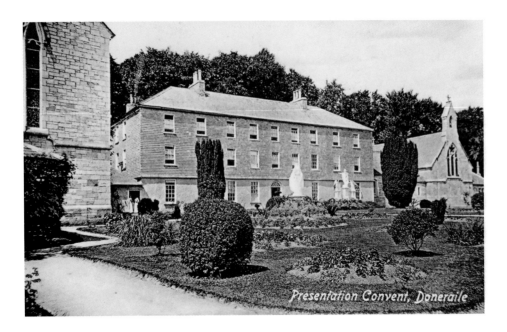

Presentation Convent, Doneraile

A Matter of Presentation

The Presentation Convent was founded in the year 1818 by Dr O'Brien. It was the first offshoot in the diocese of Cloyne from the parent house in Cork, founded by Nano Nagle. A school building was added to the convent in 1840. The sisters left Doneraile in 1992 and a lay principal, Mr Eamon Horgan, was appointed principal of the primary school. The secondary school had previously amalgamated with the Christian Brothers Secondary School to form the Nagle Rice Secondary School. In 1991 there were four nuns and two laypeople teaching in the primary school. By the following year it had a complete lay staff. The main convent building as shown in the postcard has been demolished in recent years.

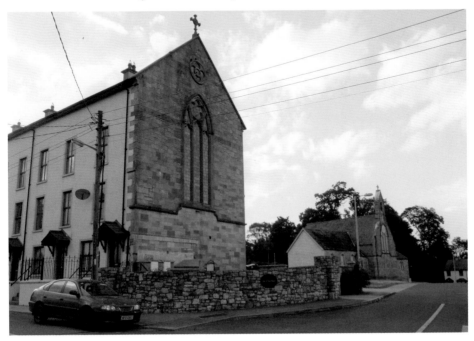

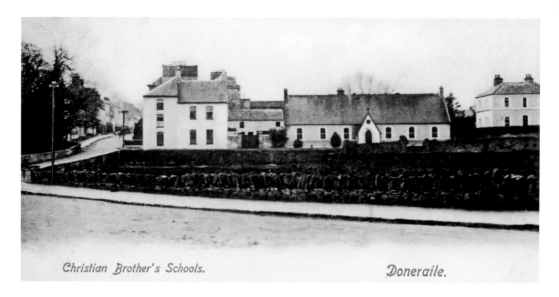

Christian Brother's Schools. *Doneraile.*

A Corner of Education

The Christian Brothers were introduced into this parish by Bishop Dr Croke in 1869, and one hundred years ago had flourishing schools under the Intermediate Commissioners; technical and manual schools under the Dublin Department and the county council; and a well-equipped scientific laboratory under the same departments. The main block of buildings (as seen in the postcard) is now vacant.

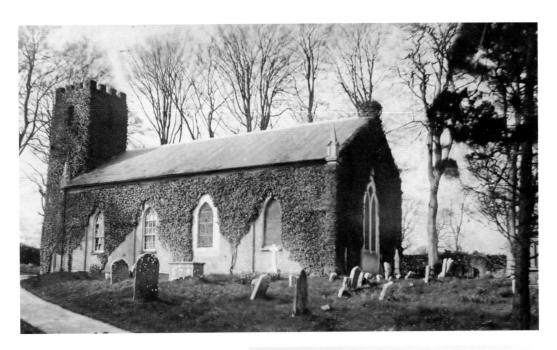

Leger's Reminder

St Mary's Church, has been used by the Church of Ireland congregation in Doneraile since it was originally built in 1633 by Sir William St Leger. His grandson, Arthur, Viscount of Doneraile, rebuilt it in 1726. The present church dates from 1816. The peel of six bells is one of the few peels existing in Irish country churches. The original spire was blown down in 1825 and replaced. Some of the St Legers are buried in the south side of the churchyard.

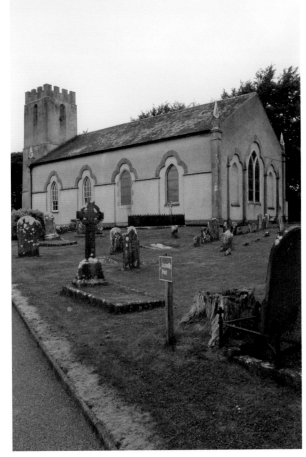

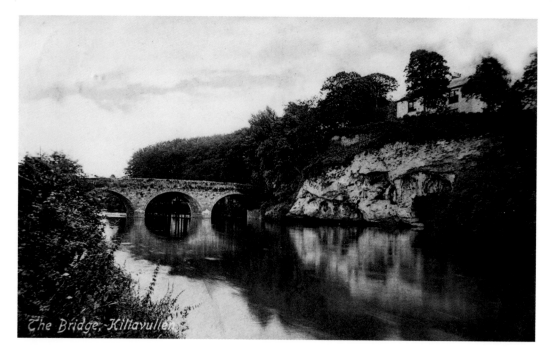

The Bridge, Killavullen

The Church of the Mill

For over 400 years, the Nagle family, of Anglo-Norman origin, exerted great influence over the Killavullen part of the Blackwater Valley through the construction of four castles and the early village of Killavullen itself. The mountain range nearby bears the Nagle name. In 1821, the village, which lies adjacent the river, had a population of 278 with fifty-four houses. In 1826 there were two schools. The parish church was built in 1839 and dedicated to St. Nicholas. A new national school was built in 1907. A large boulting mill in the village, and a large bog supplied, not alone the village, but the Mallow market with fuel.

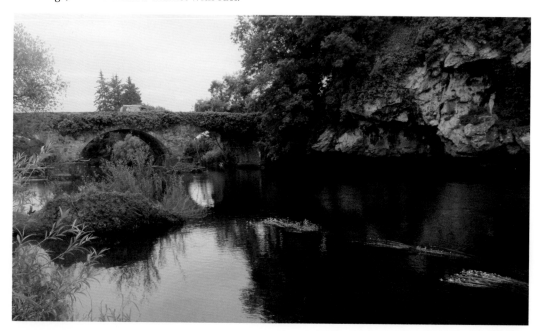

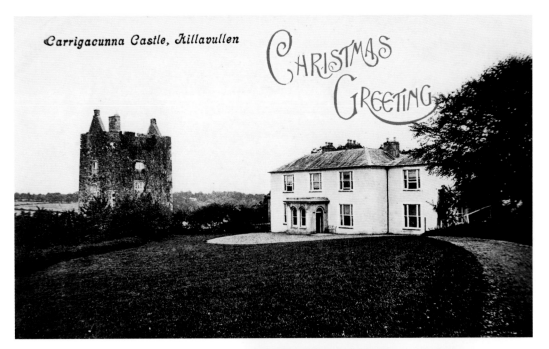

Carrigacunna Castle, Killavullen

Christmas Greeting

The Rabbit's Rock

Near Killavullen is one of a number of castles in the area erected by the Nagle family. This one, Carrigacunna (the Rabbit's Rock), was the home of Sir Richard Nagle of Clogher, one of the foremost members of the Patriot Parliament of 1689. James II is reputed to have stayed there on his way north from Kinsale. It is in a very good state of preservation and nearby, a fine Georgian house, the one-time residence of the Foott family. To the west lies the townland of Ballygriffin, (Griffin's Town), where another Nagle home, birthplace of Edmund Burke's cousin Nano Nagle, foundress of the Presentation Order of Nuns. A sign on the Mallow – Fermoy road, indicates the site of the house. Nothing remains except some of the outhouses, which have recently been incorporated in a centre built by the Order.

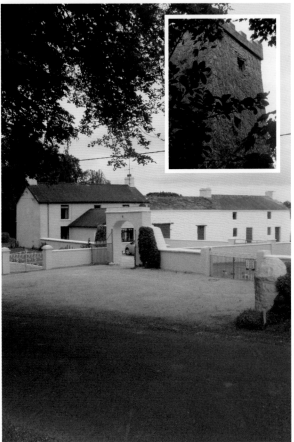

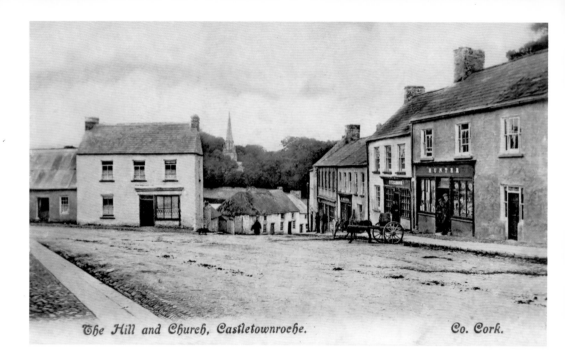

The Hill and Church, Castletownroche. *Co. Cork.*

Roche's Bastion

Castletownroche is located in a picturesque area, north-east of Killavullen, beside the Awbeg river which is a tributary of the River Blackwater. Edmund Spenser the English poet wrote of the Awbeg River in *The Faerie Queen* calling it the 'Mulla'. The first historical record about Castletownroche is from the late thirteenth century when the Anglo-Norman family of Roche established a fortress here. They were descendants of Richard FitzGodebert (Richard, son of Godebert) who came to Ireland with Anglo-Norman knight Richard de Clare nicknamed Strongbow. The fabric of the townscape incorporates many colourful buildings including the historic Spinning Wheel public house, which was first licensed in 1791.

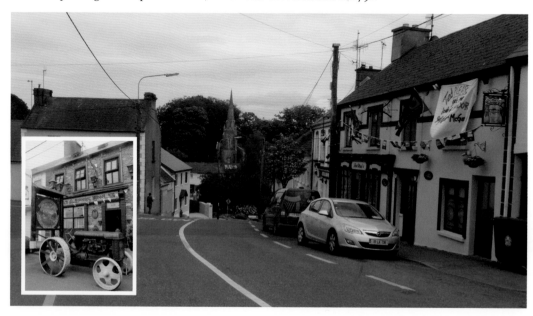

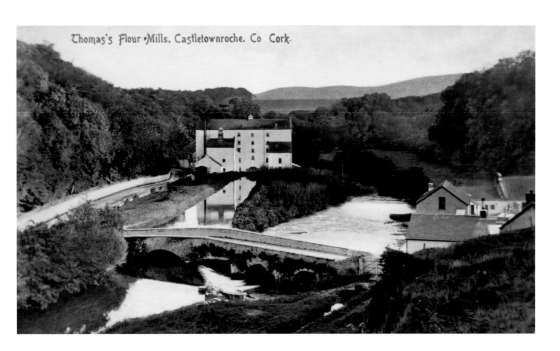

Thomas's Flour Mills, Castletownroche. Co Cork.

The Old Rustic Bridge

Incorporated into the remains of the present bridge are the vestiges of a medieval bridge. The remains can be seen in the upriver side as three semi-circular arches with three wide piers. In the eighteenth century the bridge was widened to accommodate the increase in traffic. In the nineteenth century, below the bridge were two large flour-mills. One of the old mills has been restored and now houses the Avondhu Blackwater Partnership Ltd. The company establishes or supports initiatives directed towards sustainable community development. The famous Irish ballad 'The Old Rustic Bridge by the Mill' by J. P. Keenan takes its origins from the location.

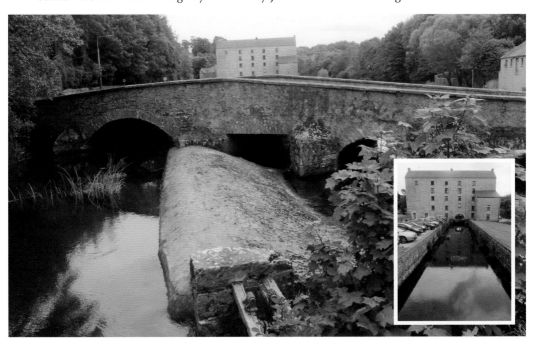

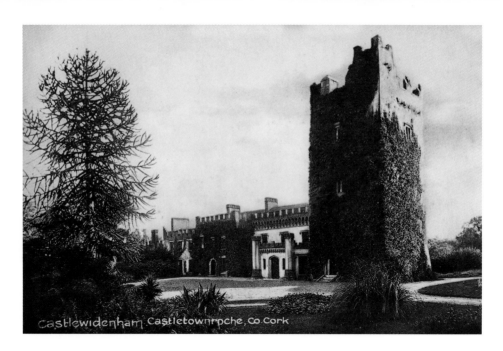

Castlewidenham Castletownrpche, Co.Cork

A Noble Mansion

In the nineteenth century, Castle Widenham was the noble mansion of H. Mitchel Smith, it is situated on the summit of a rocky eminence overhanging the river. The banks of the river were richly wooded, and commanded an extensive and varied prospect over the surrounding country. The tower or keep of the ancient fortress has been incorporated in the present structure. There is a descent to the river of a hundred steps cut in the solid rock, for supplying past inhabitants of the castle with water. Blackwater Castle, is now available to hire as a private castle experience for exclusive weddings, private parties and family gatherings. It also possesses an outdoor pursuit centre.

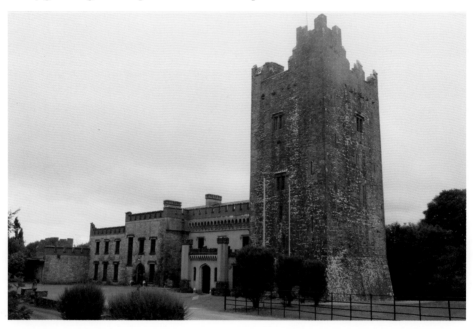

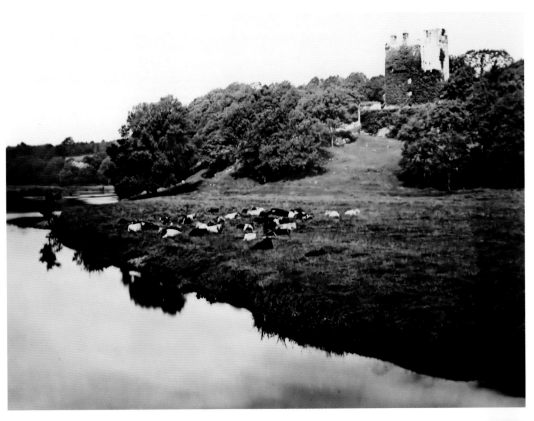

The Castle on the River

The name Ballyhooly is derived from the Irish *Béal* Áth *h'Úbhla* the ford of the apples and according to local tradition the sides of the valley here were once covered with orchards. Ballyhooly Castle was built in 1314 by the Roches a prominent Anglo-Norman family. It commanded a strategic position along the Blackwater River. In 1587 the castle was described in a report to Elizabeth I as being four storeys high, had vaulted roofs and covered in thatch.

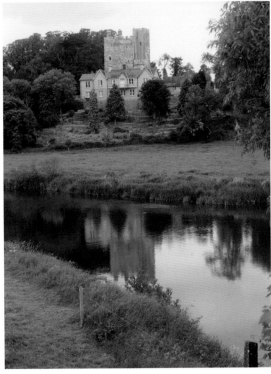

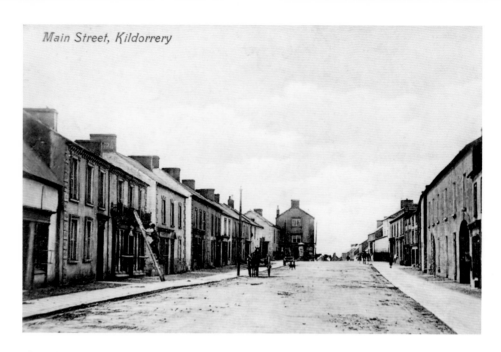

Main Street, Kildorrery

The Kingston Dream

In 1606 King James I granted permission to Maurice Fitzgibbon for a fair to be held in Kildorrery. The present-day village of Kildorrey was started in the 1780s when Robert the 2nd Earl of Kingston began a lifelong project of developing his 40,000-acre estate, which involved demolishing whole villages and replacing them with wide urban streets with two-storey houses for his tenants. It was at this time that the earl also rebuilt Mitchelstown, Ballylanders and Ballyporeen. Kildorrey is also famous for the William Gates's cream factory, which was part of a wider British baby-food manufacturing operation. Dublin-born Elizabeth Bowen (1899–1973), Anglo-Irish novelist and short-story writer, spent her summers at her beloved ancestral home located nearby at Bowen's Court. She wrote over forty books in her career and is highly regarded in the literary world.

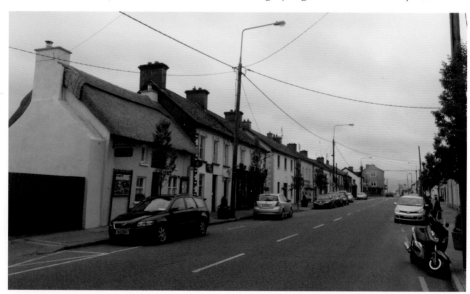

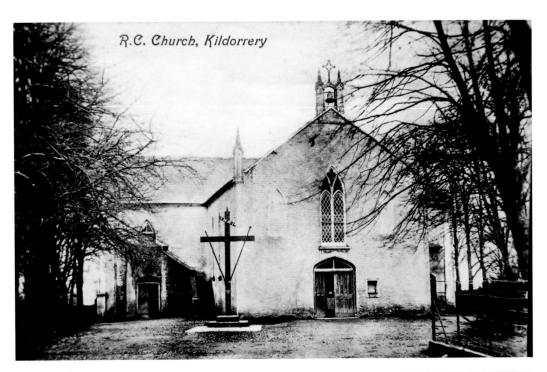

R.C. Church, Kildorrery

Churches and Battles

St Bartholomew's Roman Catholic church, Kildorrey, was constructed around 1838–39. It still bears the scars of an incident in the Irish War of Independence when British forces attacked it in a gun battle with the Irish Republican Army. Bullet marks are still visible on the outside of the nave. An earlier church ruin, believed to date from the thirteenth century, can be viewed on the edge of the town complete with carved stones of people's faces.

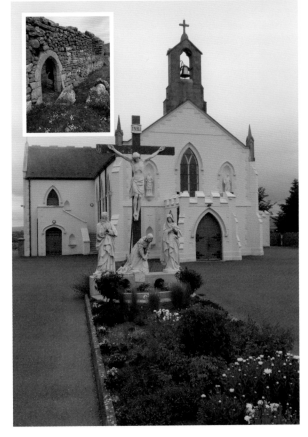

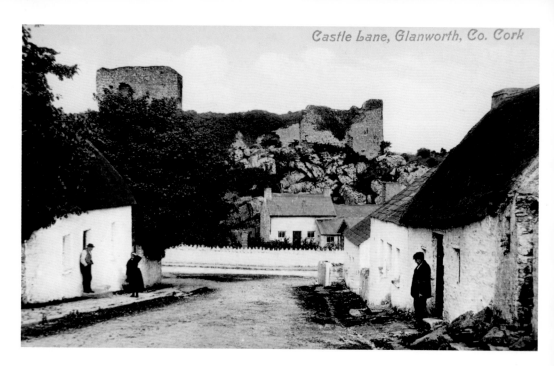

Glanworth Castle

On a rocky eminence on the western side of the Funcheon River, a tributary of the Blackwater are the extensive ruins of Glanworth Castle, an ancient seat of the Roche family. Through excavations and ground surveys, the ruins consist of an ancient square keep of considerable strength, and the remains of another building of more recent date and superior construction, apparently containing the state apartments. They are all enclosed by strong walls, nearly six feet in thickness, and defended at each angle by a round tower. The nearby Glanworth Bridge is a rare example of a medieval bridge and is the oldest and narrowest working road bridge in Europe.

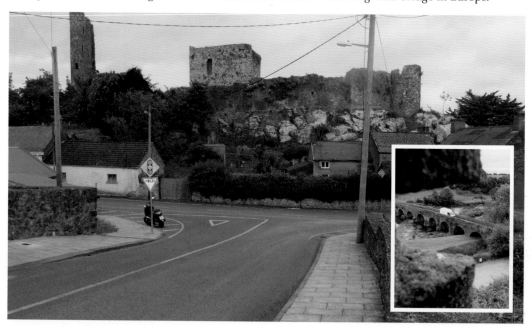

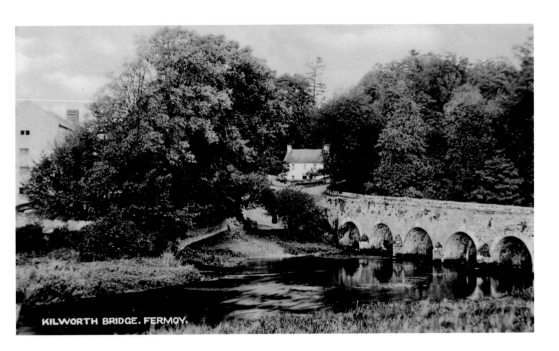

KILWORTH BRIDGE. FERMOY.

Reordering the Landscape

Kilworth, *Cill Uird*, or the 'church of the order' was founded by St Colman, a disciple of St Mochuda of Lismore, in around AD 636. Following the twelfth-century Anglo-Norman invasion of Ireland, Kilworth and its surrounding areas fell into the hands of a number of different families – Flemings, Roches and Condons – all of whom would go on to become well-known landowners throughout the Blackwater valley.

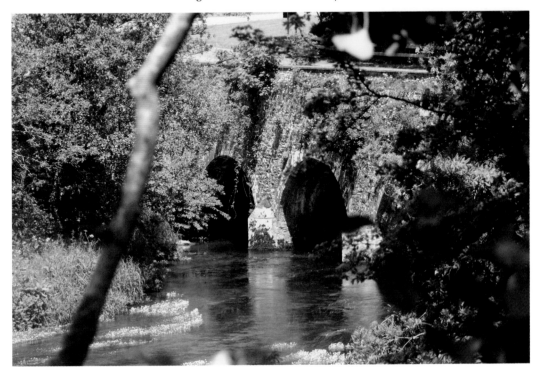

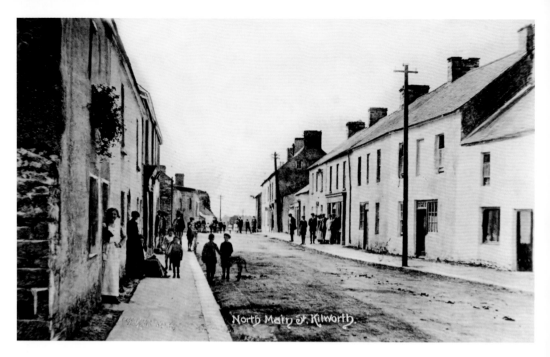

Kilworth Lands

Following the Desmond Rebellion, and a period during which the land was passed back and forth between the Condons and the Fleetwoods, the Condon estates were sold to Stephen Moore of Clonmel. Under his ownership much of these lands became known as Moore Park. The demesne wall is still intact in places, but the land now belongs to An Teagasc, who run an agricultural research centre on the site.

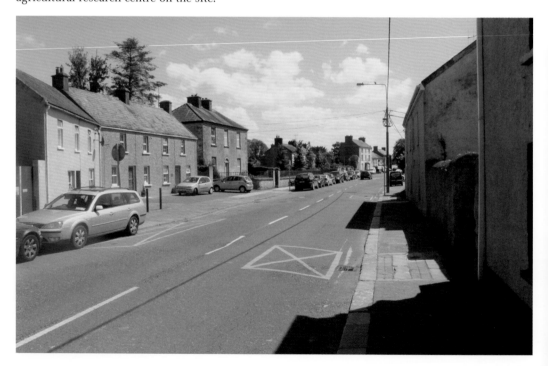

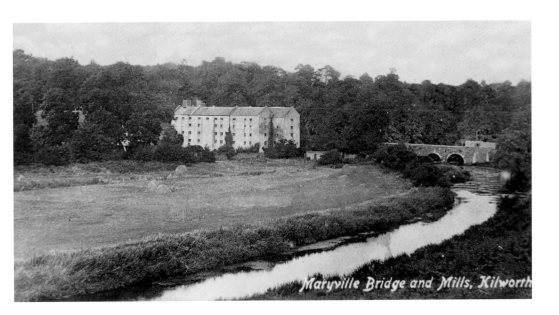

Maryville Bridge and Mills, Kilworth

Kilworth Bridge and Mill

The village is situated on the River Funcheon, over which is a neat stone bridge of six arches, about a mile above its confluence with the Blackwater. It is sheltered by a low mountain ridge, which rises immediately behind it. In the nineteenth century, there were several mills on the river, the principal of which was the Maryville flour mills, the property of Laurence Corban who employed twenty to thirty men, and produced annually about 12,000 barrels of flour; there was also a flax mill belonging to Dr Collet, and adjoining the town is a mill for oatmeal. The mill in the old postcard is now demolished but is marked by a stone installation archway via the owners of the site.

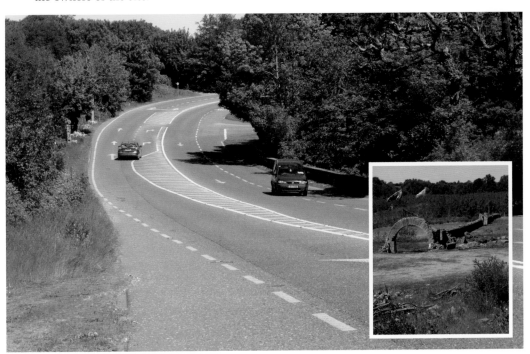

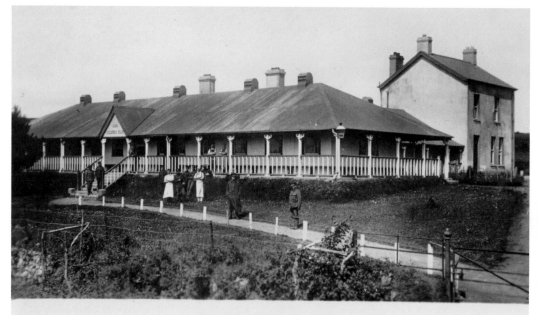

SOLDIERS' HOME, KILWORTH CAMP.

Training in the Hills

At one time a bustling market town, by the nineteenth century Kilworth was in decline. The closure of the Bianconi coach routes, the subsequent disappearance of the attending passing trade and the continued growth of nearby Fermoy were a death knell for the area. The village experienced a resurgence of sorts with the arrival of the British military garrisons. In 1896, around 14,000 acres of the hills of Kilworth was purchased as a summer training camp. The ruins of the above building are shown in the modern-day picture.

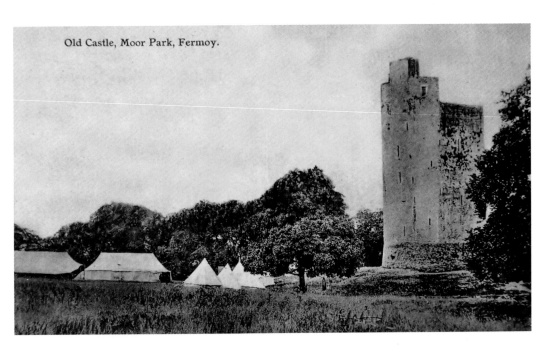

Old Castle, Moor Park, Fermoy.

A Curvaceous Story

Cloghleigh Castle provided the setting for an army encampment in the above postcard dating from 1914. The castle's name translates as 'Castle of the Greystone', was the principal stronghold of the Anglo-Norman family of Condons. Fast-forward in time and the castle was sold with the Cork estates by Henry Fleetwood to Stephen Moore in 1684 and passed in time to the British War Department.

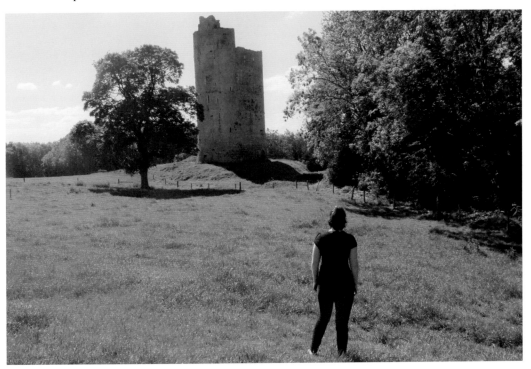

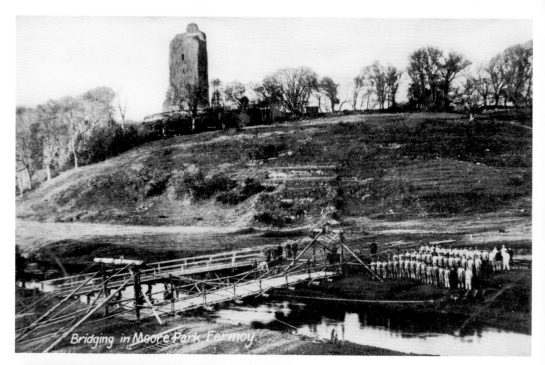

Bridging in Moore Park Fermoy.

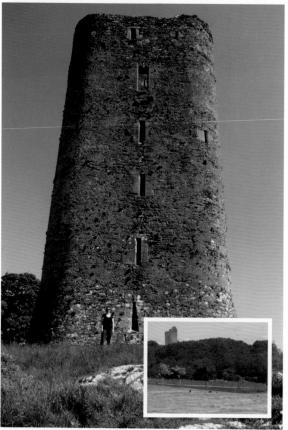

Creating a Training Centre

By 1915, Moorepark was one of the main centres of military training for the 16th Division. First World War training trenches and hundreds of temporary cabins were erected to form a greatly expanded training facility. The presence of soldiers gave an enormous boost to local trade. Everything from fodder for horses to bread and porter for the soldiers had to be supplied from the locality. Today around 4,500 members of the Irish defence forces are assigned to Kilworth for training every year, including the Naval Service and Ranger Wing.

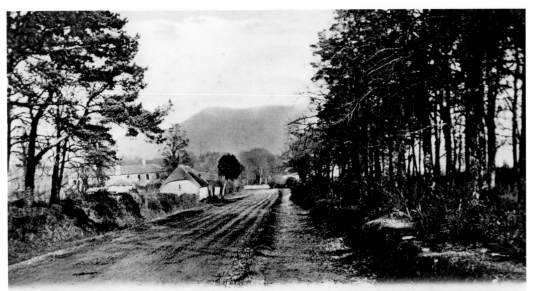

Mitchelstown. Galtee Mountains from Fermoy Rd.

Getting to the Galtees

Mitchelstown, just 30 miles from Cork City, is set at the foothills of the Galtee Mountains, in the beautiful countryside of Ireland's Blackwater Valley. The scenic Galtee Mountains are spread across the borders of three counties in Munster: Limerick, Tipperary and Cork. The name for this range of mountains was derived from the Irish *Sléibhte na gCoillte*, or 'mountains of the forests'. Galtymore is the highest peak in the range, reaching 3,009 feet, and is situated the border between Limerick and Tipperary. Glacial action during the last Ice Age helped to form various features of the Galtees.

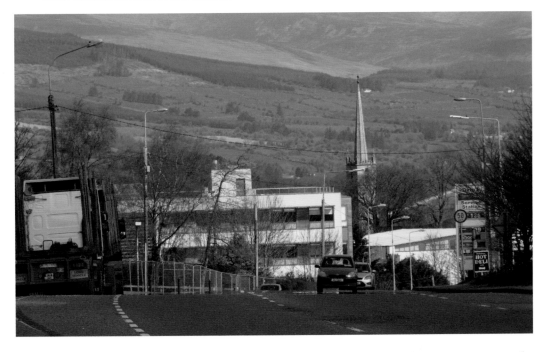

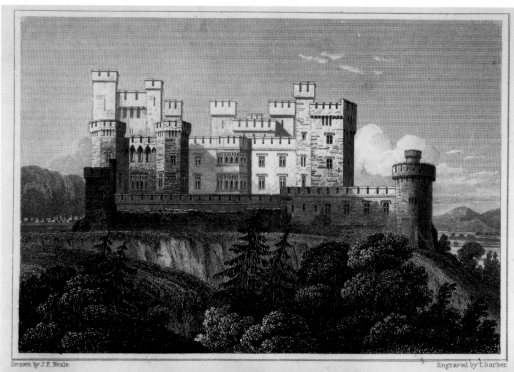

Drawn by J.P. Neale.

Engraved by T. Barber

Printed by Bishop & Son.

MITCHELSTOWN CASTLE.
(CORK)
IRELAND.

London, Pub. June 1st 1825, by J.P. Neale, 16. Bennett St, Blackfriars Road, & Sherwood, Jones & Co. Paternoster Row.

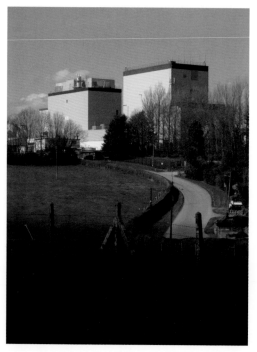

The White Knight's Abode

Mitchelstown Castle formed part of the extensive possessions of the White Knight, otherwise called Clongibbon, from whom part of the barony derived its name, and who was descended by a second marriage from John Fitzgerald, ancestor of the illustrious houses of Kildare and Desmond. The White Knight erected here a castle, which was reduced by rebellions in 1641, but was retaken by the English, and was afterwards besieged by the Earl of Castlehaven, to whom it surrendered in 1645. Margaret Fitzgerald, who was sole heiress of the White Knight, married Sir William Fenton, and their only daughter conveyed this portion of the estates by marriage to Sir John King, who was created Baron Kingston by Charles II in 1660 and was ancestor of the present earl of Kingston. On 12 August 1922, Mitchelstown Castle was burned by the Irish Republican Army. The site is now occupied by Dairygold Food Co-operative Society's Factory.

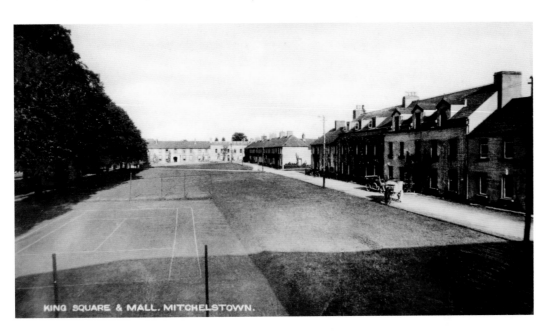

KING SQUARE & MALL. MITCHELSTOWN.

A Planned Square

King Square could be found at the entrance to Mitchelstown Castle in olden times but now only the entrance wall remains of the castle. The town's name derives from St Michael, the patron saint of the Condon family, who lived hereabouts in medieval times. It is an important example of a planned town and was laid out primarily by the 1st and 3rd Earls of Kingston in the late eighteenth and early nineteenth centuries. Their family, the King family, had acquired the town through the marriage of Sir John King, 1st Baron Kingston, to the heir of the Earl of Desmond's estates.

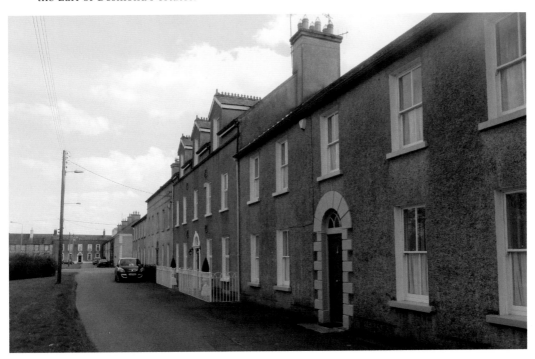

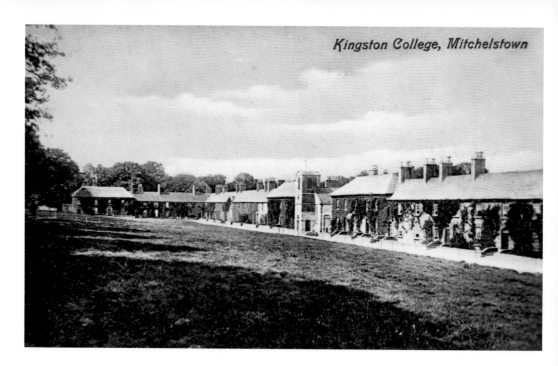

Kingston College, Mitchelstown

In Aid of Charity

King Square and Kingston College form the finest Georgian square in any small town in Ireland. Designed by architect, John Morrison, the college was built in 1782 by James King, 4th Baron Kingston (1693–1761) who provided in his will for the building of a chapel and college of alms houses for 'poor Gentlemen and Gentlewomen members of the Church of Ireland as by law established'. The term 'college' in this case refers to people living under a common rule. It was never an educational institution.

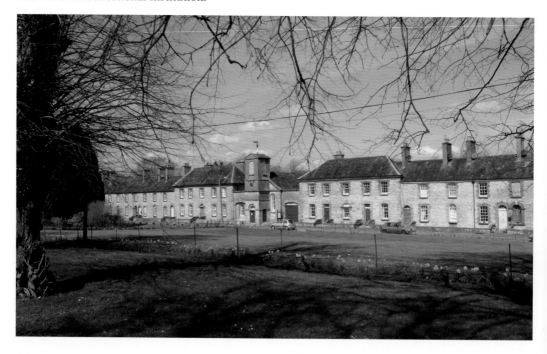

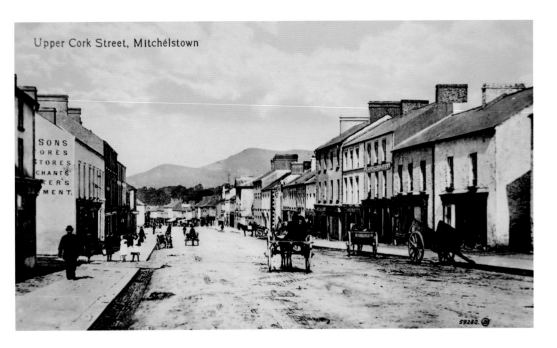

Upper Cork Street

Mitchelstown is an important example of a planned town and was laid out primarily by the 1st and 3rd Earls of Kingston in the late eighteenth and early nineteenth centuries. Two principal streets emerged, respectively George's Street and Cork Street, of which the latter is the chief thoroughfare, and the former is terminated by the church at the southern extremity, and at the other leads into a spacious and handsome square, the north side of which is occupied by the extensive buildings of Kingston College. The Kingstons also planned a new road to Lismore, and a continuation of the line to Limerick was opened, which gave access to an extensive, fertile and improving district.

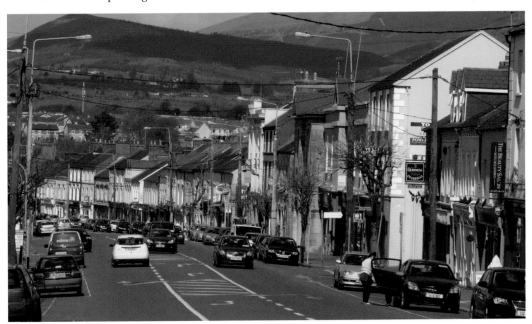

67

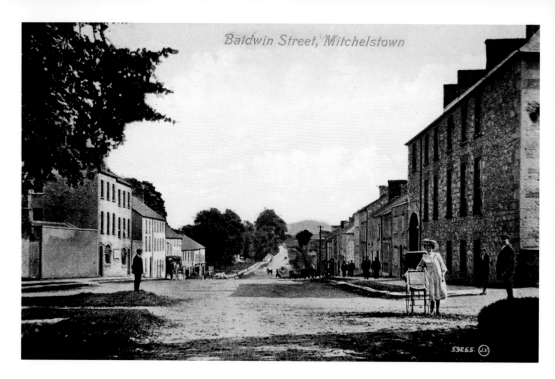

Baldwin Street

A glance at a County of Cork directory for 1915 shows several trades on the Kingston-created Baldwin Street; these included James Russell's auctioneer, Patrick O'Neil's arms and ammunition dealer, P. Farrell's bakery, Hannah Casey's egg merchant premises, P. O'Neil's furnishing warehouse, grocers and provision merchants (three), Patrick O'Neil's hardware merchant shop, insurance agents (two) and solicitors (two).

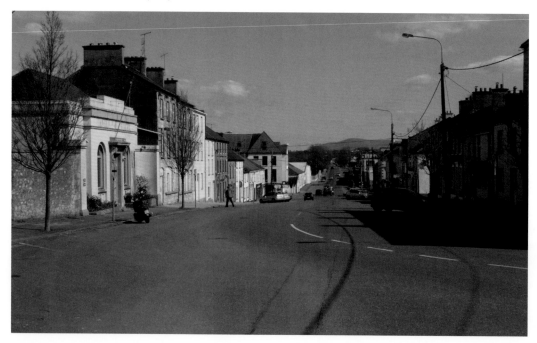

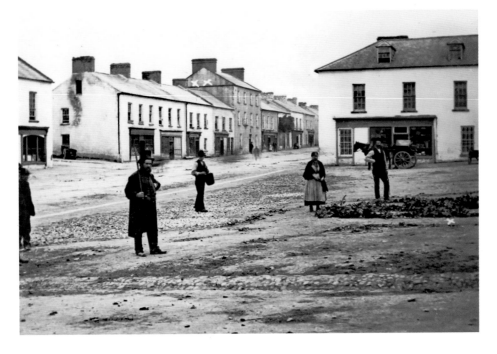

Mandeville's Movement

In the Land Wars of the 1880s, Carrick-on-Suir-born and Mitchelstown farmer John Mandeville (1849–88) led the tenants of the Kingston estate in their campaign to obtain fair rents, fixity of tenure and the right to sell on the interest in their holdings. Along with his close friend, William O'Brien, MP, Mandeville had urged tenants to resist eviction at public rallies in Mitchelstown during August 1887. He was jailed for these rallies. The Mandeville Sculpture was unveiled in 1906 before a crowd of 20,000 people. It comprises a bronze statue set on stepped limestone plinth with lettering to panelled faces and to plinth.

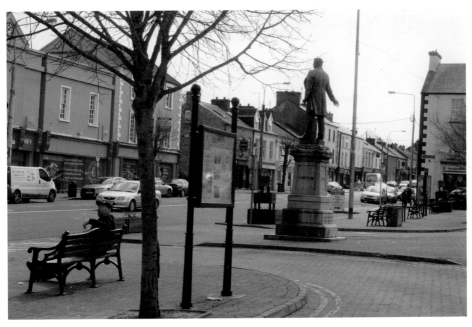

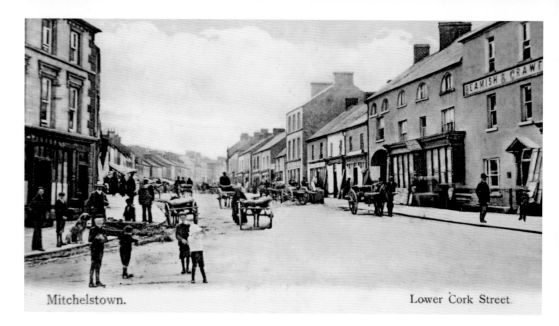

Mitchelstown. Lower Cork Street.

Lower Cork Street

A County Cork street directory for 1915 lists a number of trades in operation on Lower Cork Street, Mitchelstown: Arms and ammunition dealer (one), bakers (nine), boot and shoemakers (three), chemists (three), coal merchant (one), confectioners (two), drapers (six), dressmaker (one), egg merchant (one), furnishing warehouses (two), O'Brien's Hotel (one), glass, china, and earthenware dealer (one), grocer and provision merchant (twenty-one), hardware merchants (three), insurance agents (two), jeweller (one), leather merchants (two), oil and colour merchants (two), physician and surgeon (one), saddlers (one), seed merchants (four), stationers (three), timber and slate merchants (one), undertaker (one), victuallers (three), vintners (seven), and wine and spirit merchant (one). The last action against British forces during the War of Independence took place at this junction (seen in the modern-day photograph) on Sunday 11 July 1921, an hour before the truce came into effect.

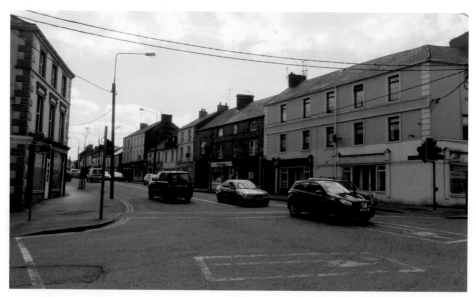

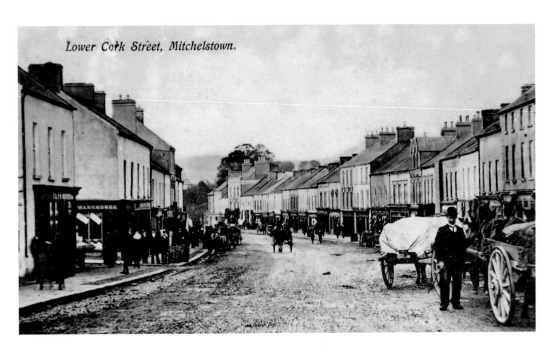

Lower Cork Street, Mitchelstown.

The Home of Good Food

In 1919, farmers founded Mitchelstown Co-operative Agricultural Society as a store for selling farm supplies. It opened its first creamery in 1925. Seven years later, Mitchelstown Creameries became the first Irish company to manufacture processed cheese. By 1940, it had become the biggest industry in the area and the biggest co-operative society in Ireland. With its advertising slogan, 'Mitchelstown, the Home of Good Cheese', it dominated the Irish cheese market. It also became the biggest producer of dairy and pork products with brand names such as Galtee, Mitchelstown and Dairygold. Dairygold Co-op was formed in 1990 when Mitchelstown merged with Ballyclough.

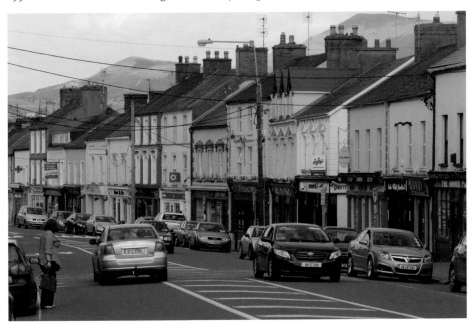

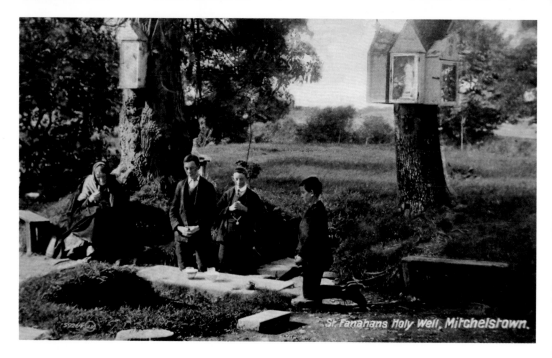

St. Fanahans Holy Well, Mitchelstown.

A Site of Pilgrimage

Fanahan or *Fionn Cú*, translated as the White Hound, came to the local townland of Brigown in the seventh century and founded a monastery there. St Fanahan died in around AD 660. A cult of prayer and pilgrimage developed at St Fanahan's Well, just a short distance from the ruins of Brigown Church, which is all that is now left of the monastic settlement founded by the saint. The sculpture of Fanahan on upper Cork Street was carved by Cliondna Cussen in 1981.

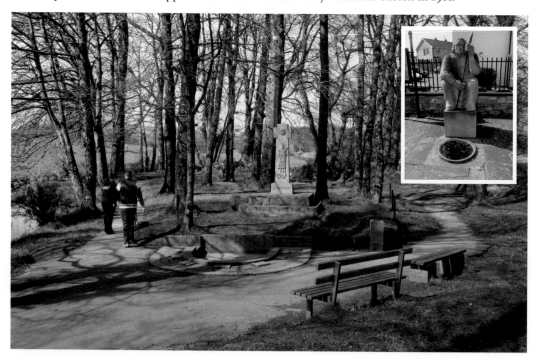

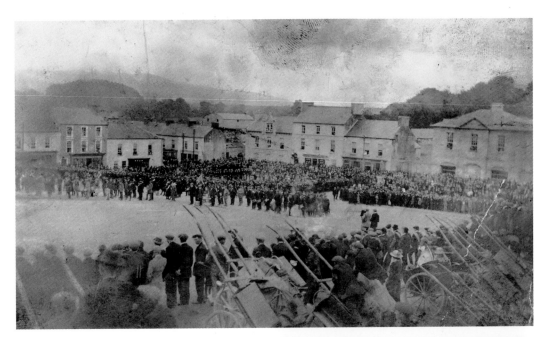

Volunteers for a Cause

The Irish Volunteers were formed in Mitchelstown in April, 1911. There were two political organisations in the town – O'Brienites (All for Ireland League) and Redmondites (Ancient Order of Hibernians). The first meeting was held in the Town Hall. About forty people attended. Companies of the Irish Volunteers were also formed in Anglesboro, Ballylanders, Galbally, Kilfinane, Knocklong, Ardpatrick. These units, with Mitchelstown, later formed the Galtee Battalion. In addition to these companies, units were also organised at this time in Fermoy. The Mitchelstown company was divided into squads and sections, and under the command of James O'Neill.

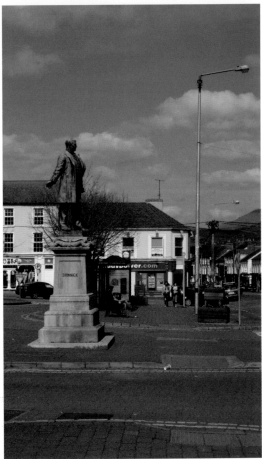

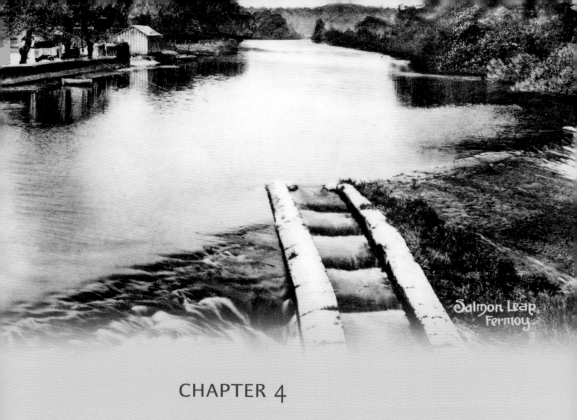

CHAPTER 4

Fermoy Crossroads

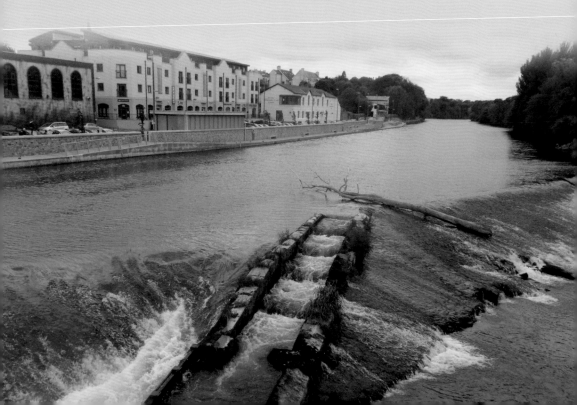

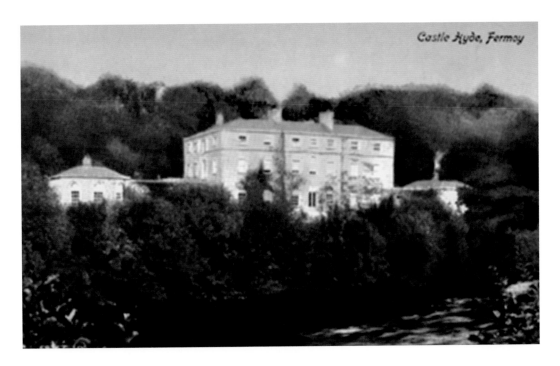

A Colourful History

The estate of Castle Hyde has a very long history. There is the ruin of a Norman castle dating from 1301 on top of the cliff just behind the present house. The Hyde family, who gave their name to the estate, in fact became bankrupt trying to maintain the estate and had to sell in the mid-nineteenth century, and the house has had several owners of colourful character since then. The present main block of Castle Hyde house dates from 1760, with extensions designed by Cork architect Abraham Hargraves the elder some forty years later. Completed in 1801, the house is in the Palladian style of architecture.

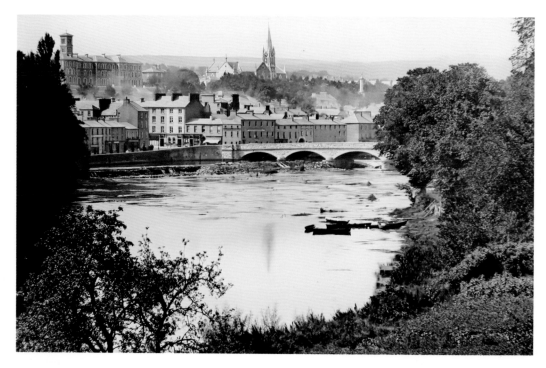

The Plain of Fermoy

The ancient Gaelic name, *Feara-muighe-Féine*, signifying 'Men of the Plain,' has been anglicised over time to Fermoy. Following the Anglo-Norman invasion, the territory was given to the Flemings from whom it later passed to the Roches. It is said that it originated on the foundation of a Cistercian abbey founded by the family of the Roches, in 1170, which was known as the Abbey of Our Lady de Castro Dei.

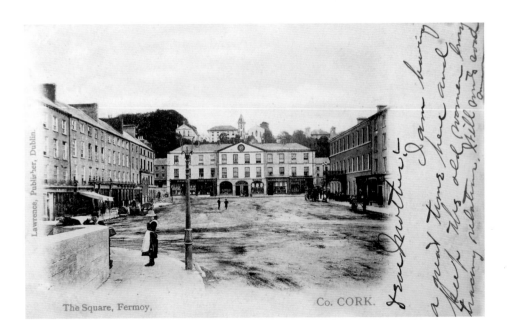

Lawrence, Publisher, Dublin.

The Square, Fermoy, Co. CORK.

A Passing Through Time

Fermoy town centre now stands on what was once the Abbey lands. Following the dissolution of the monasteries, Elizabeth I gave the Abbey lands of Fermoy to Sir Richard Grenville, a cousin of Sir Walter Raleigh, in 1591. In 1621, Sir Bernard Grenville, Sir Richard's eldest son, sold the lands of Fermoy to Sir Lionel Cranfield (later the earl of Middlesex and lord treasurer of England). In 1624, Sir George Harvey purchased the lands of Fermoy on behalf of Sir Richard Boyle, 1st Earl of Cork. The town, which commanded an important pass of the river, over which a bridge had been erected, was, in 1690, attacked by 1500 of the Irish in the service of James II, commanded by Gen. Carroll.

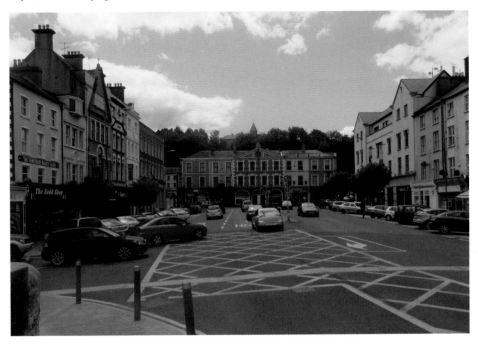

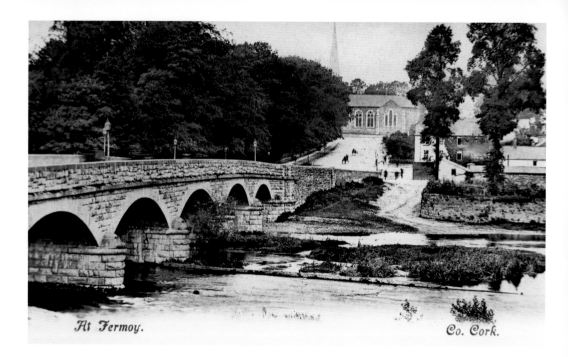

At Fermoy. Co. Cork.

A Bridging Point

At the close of the eighteenth century, the town consisted of a common carrier's inn and a few mud cabins only; but, in 1791, John Anderson, having purchased four-sixths of the manor, erected a comfortable hotel and some good houses, and laid the foundation of the town's early prosperity. The handsome stone bridge of thirteen arches over the Blackwater was also widened by Anderson.

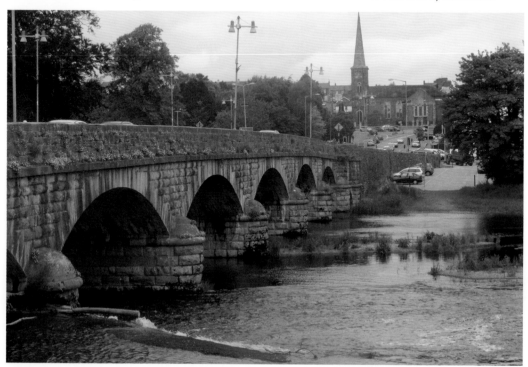

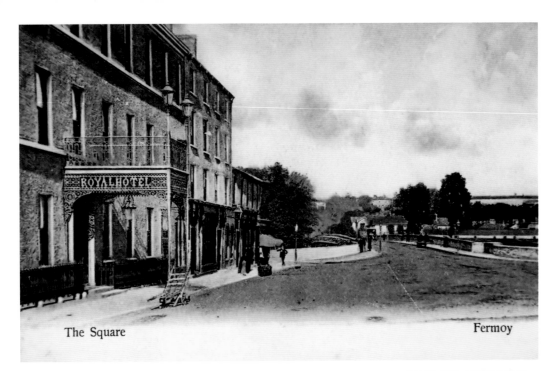

The Square Fermoy

Anderson's Amenities

Adjoining the bridge is the entrance to Fermoy House, the residence of John Anderson, to whom not only the town owes its prosperity, but also the entire country. Both are indebted to Anderson for the important advantages resulting from the introduction of the mail coach system and the formation of many new and useful lines of road. John Anderson built a hotel on the square to replace the old 'carman's' inn and associated with it was built a coach station, post office, livery stables and the mail coach factory. The sculptures in Fermoy celebrate the history of the coaches and John Anderson.

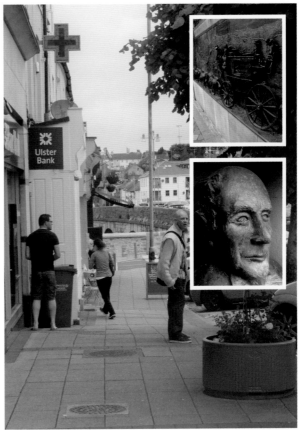

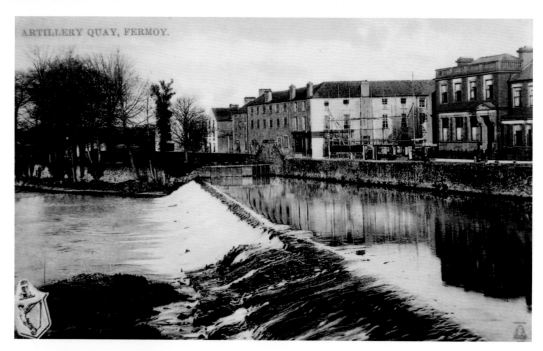

ARTILLERY QUAY, FERMOY.

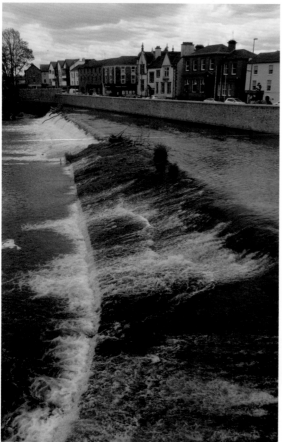

Artillery Quay

In 1797, the government, wishing to form a military station in a central part of the south of Ireland, spoke to John Anderson who, foreseeing the advantages to be derived from such an establishment, made a free grant of a site for that purpose, and allowed the erection of temporary barracks on the south side of the Blackwater River.

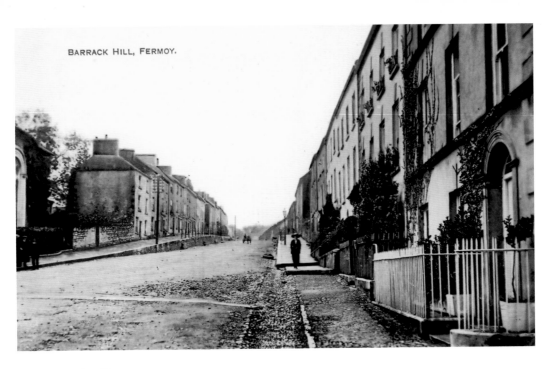

BARRACK HILL, FERMOY.

Barrack Hill

The military strength based in Fermoy varied over the years, fluctuating with the political scene as it was affected by the British Empire. The largest number of troops ever to be stationed in Fermoy would have probably been before the Battle of Waterloo in 1815. The Duke of Wellington visited the barracks at that time and it was from Fermoy Barracks that a very large contingent of the troops left to do battle against Napoleon. Waterloo Lane which runs down to the river at the corner of the old Vocational School, now Scoil de hÍde, commemorates their departure.

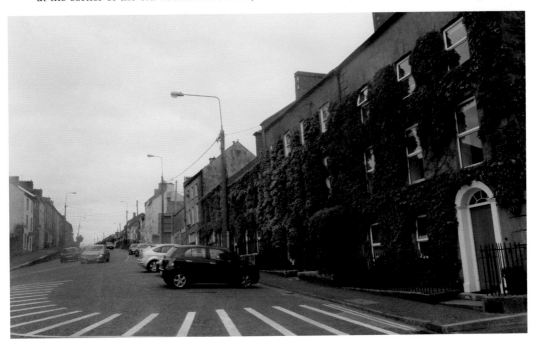

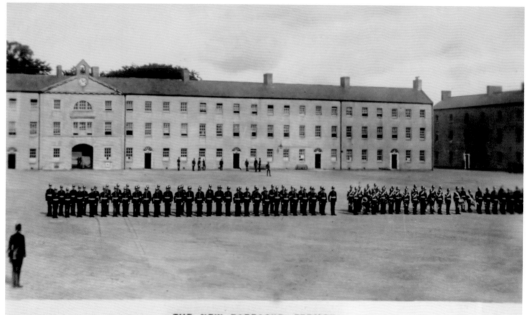

THE NEW BARRACKS, FERMOY.

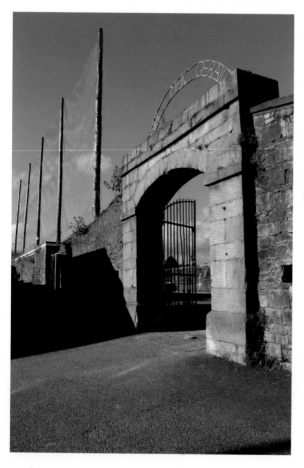

The Barracks of Fermoy
John Anderson, Landlord of Fermoy and Buttevant, gave 40 acres rent free on which the barracks of these towns were built. He secured for Fermoy not one but two large barracks. The East Barracks, covering 16½ acres and costing £50,000 were completed in 1806, and in 1808 a barrack master was appointed by the barrack board and board of works. The west or new barracks, which included a small hospital, was completed in 1809.

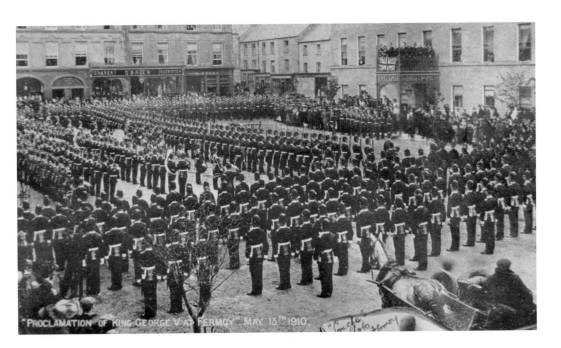

"PROCLAMATION OF KING GEORGE V AT FERMOY" MAY 15TH 1910.

Proclamations and Change

The old postcard above shows a display of loyalty in Fermoy town to the newly proclaimed King George V and the British crown in Fermoy on 13 May 1910. Displays of Union Jack flags and pomp and ceremony defined the event. In 1919, the British garrison at Fermoy stood at 4,300 professional officers and soldiers, plus 490 armed policemen. Within three years, all was to change. The buildings were burnt out on August 1922 during the Irish Civil War by Free State nationalists. The site is now the home of Fermoy GAA Club with only the walls and entrances surviving of the old barracks.

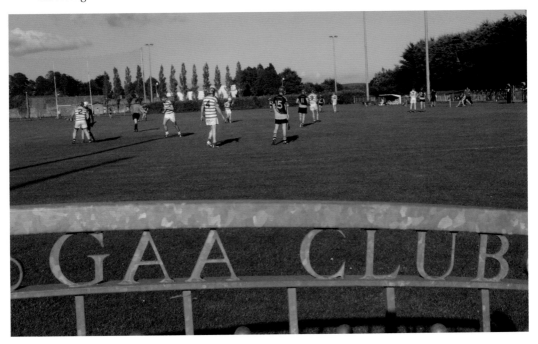

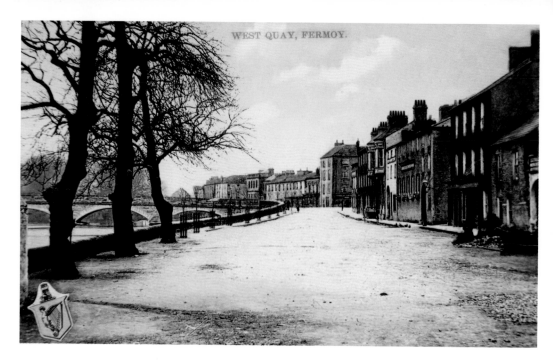
WEST QUAY, FERMOY.

A Staple Trade

Over a hundred years ago in Fermoy, there were extensive flour mills, paper-mills, and a public brewery, with a large malting establishment attached to it, celebrated for its ale and for brewing porter. The staple trade of the town was in corn and butter, of which considerable quantities were sold. A great impediment to its commercial prosperity resulted from the want of water conveyance, the Blackwater not being navigable within many miles of the town. Coal and culm were brought by lighters to Tallow, and then by land carriage to Fermoy, a distance of ten miles.

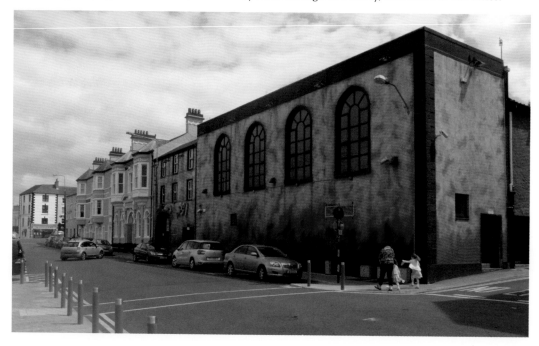

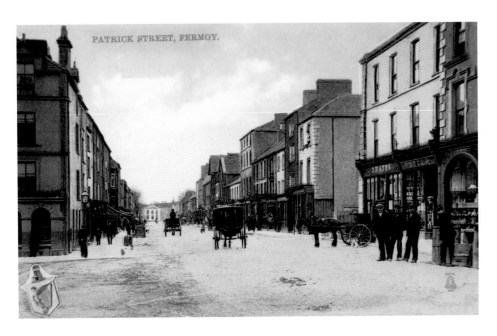

A Street of Trades

One hundred years ago, Patrick Street in Fermoy was a bustling place. Among the trades listed in the 1915 directory of County Cork were bakers (four), boot and shoe merchants (three), bottling stores (three), carriers and car owners (two), clothiers (four), China, glass and earthenware dealers (three), confectioners (two), Barry & Sons Corn Mills, John Rahilly Dairy, drapers (six), dress-makers and milliners (two), dyers' agents (one), electrical engineer (one), emigration agent (four), Flanagan fishing tackle warehouse (one), flour and meal dealers (six), forage merchant (one), fruiterers (three), furnishing warehouses (two), grocers (eleven), ironmongers (two), vintners (eighteen), physicians and surgeons (one), solicitors (two) and veterinary surgeon (one).

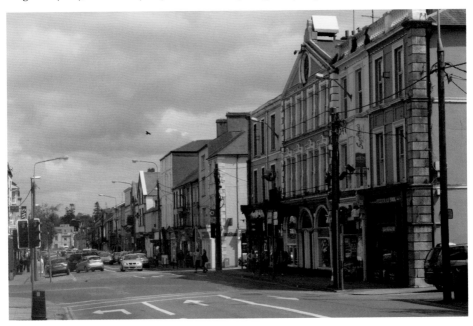

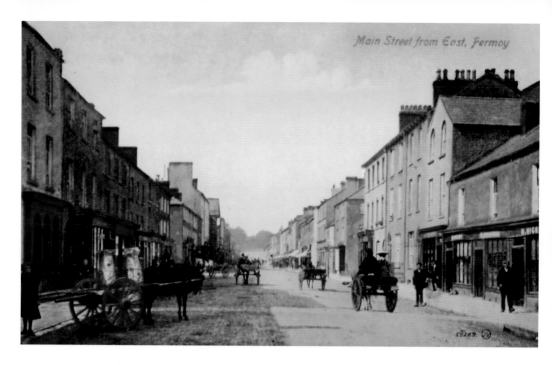

Street Narratives

Main Street, Fermoy was also known as King Street. One hundred years ago it boasted a myriad of trades. These included bakers (five), blacksmiths (two), boot and shoemaker (three), Patrick Walsh builders and contractors, carpenters (two), china, glass and earthenware dealers (two), William Troy's commission agency, confectioners (two), O'Mahony and Company Cycle Depot, Aird's Fish merchants, flour and meal dealers (two), grocers (six), hair dressers (two), hosiers and haberdashers (three) and J. Lane's pharmaceutical chemist.

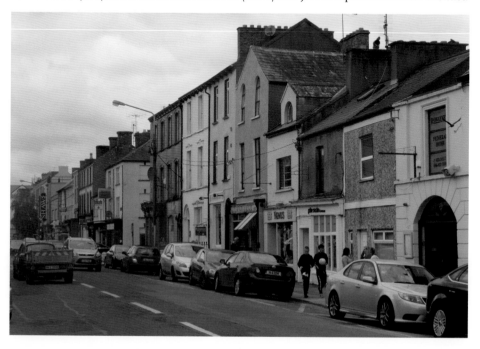

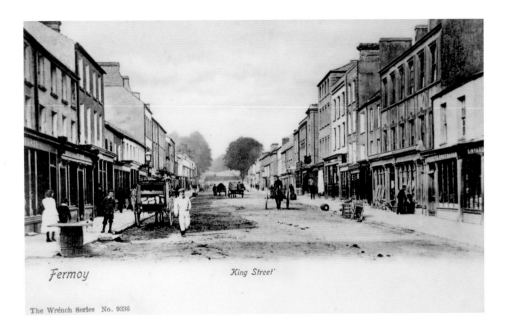

Fermoy

King Street

The Wrénch Series No. 9336

Trade on King Street

Trades from one hundred years ago on King Street, Fermoy also comprised Mrs Prendergast's Blackwater View hotel, Peter Baylor's ironmongery, J. J. Doody's ladies underclothing, Miss Quinlan's boarding and lodging house, marine store dealers (two), Miss Hyland's music teaching room, Michael Lynch's newsagency, Peter Baylor's oil and colour stores, J. J. Harris photography, printers and stationers (two), Peter Baylor's seed and manure merchant shop, shop keepers (two), tailors (three), tobacconists (three), vintners (fifteen) and D O'Regan's Wine and spirit merchants. Many of the latter trades have since disappeared off the streetscape but the main street still exhibits vibrancy and variety of trades and professions.

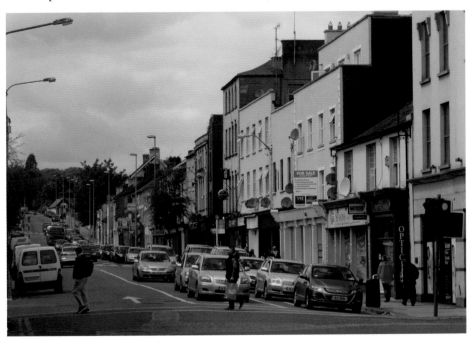

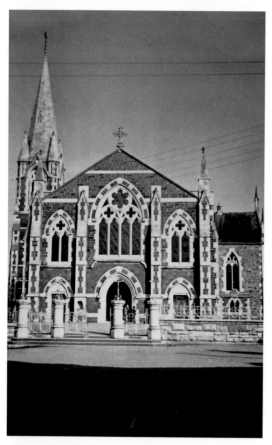

Buttresses of the Past

St Patrick's church, Fermoy was designed by the Pain brothers in 1836, the interior is Gothic in style with later fittings by Samuel F. Hynes. The exterior however is by E. W. Pugin and G. C. Ashlin who were commissioned in 1867 to add the tower, spire and other details. The chief difficulty presented to the architects was the great width of the nave and the flat lines of the roof, and this was overcome by breaking up the west front with buttresses. The architects also deemed it better to place the tower and spire at the transept, as a roadway opens immediately opposite, thereby giving it a full view of it from the town.

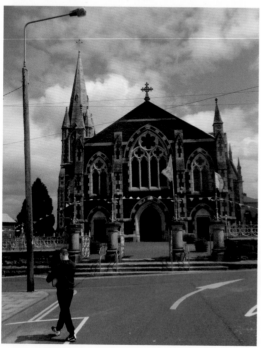

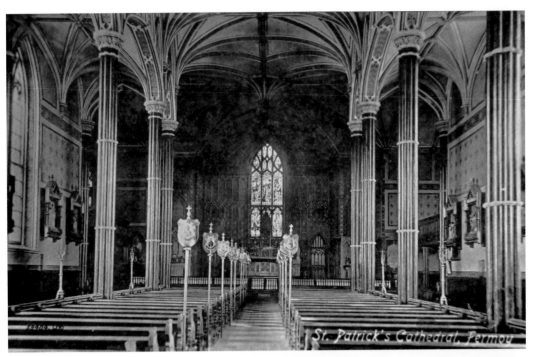

St Patrick's Cathedral, Fermoy

Architects and Designs

One of the architects of St Patrick's church was George Richard Pain. He was born in London around 1793, was a younger brother of James Pain, whom he either accompanied or followed to Ireland – probably in or after 1814. Initially he lived, like James, in Limerick, where he was granted the franchise on 29 January 1817, but he eventually made his base in Cork. The two brothers worked in close partnership and together established a highly successful practice in the south of Ireland. George Richard exhibited architectural designs at the Royal Academy between 1810 and 1814, and was awarded the gold medal of the Royal Society of Arts in 1812.

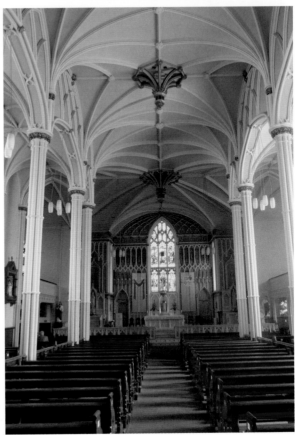

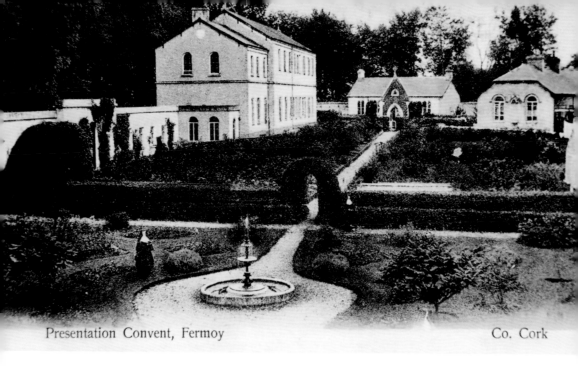

Presentation Convent, Fermoy Co. Cork

Convent Stories

The Presentation Convent at Fermoy is a detached eight-bay two-storey former house, built around 1840. The large scale and site of this convent make it a prominent feature on the Fermoy townscape. It forms a group with the former gate lodge to the south-west and the large number of ecclesiastical structures in the vicinity, such as the Loreto Convent to the west and the former monastery to the south-west. The building is now owned by the diocese of Cloyne and is leased by the Cork Education Training Board. It can be viewed above the main market square in Fermoy.

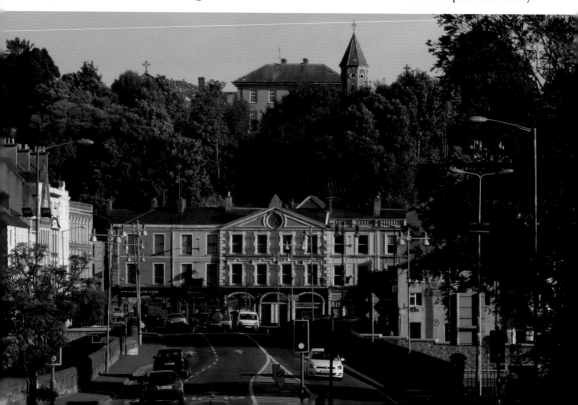

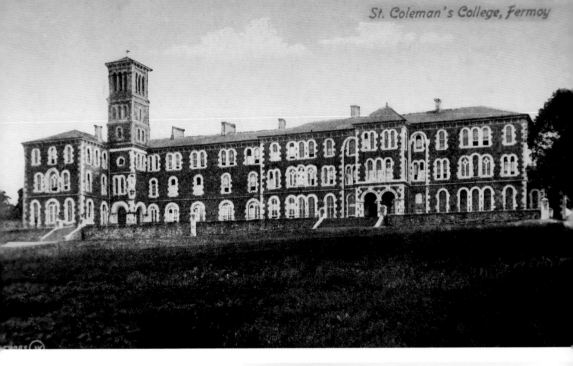

Croke, Colman and Culture

St Colman's College, Fermoy was opened in 1858 as the Diocesan College of Cloyne. The Most Revd Thomas W. Croke DD, was first president of St Colman's College 1858–66, Archbishop of Cashel, 1875–02. At the first meeting of the Gaelic Athletic Association, the new committee nominated Dr Croke, as its first patron. An Irish nationalist and popular public figure, he was deeply involved in the Land War, the struggle for home rule, and the foundation of the GAA itself.

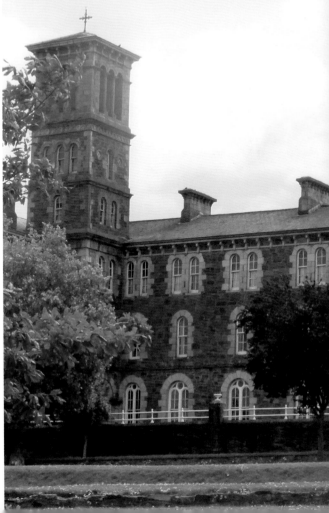

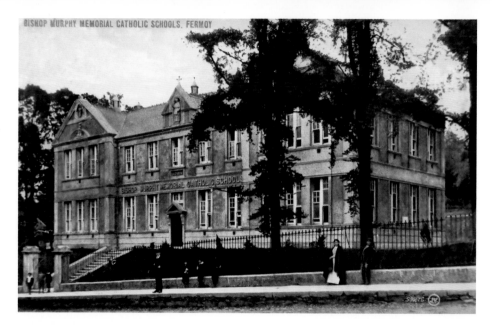

A Monument to Education

Bishop Murphy Memorial School was built in 1904 and formally opened in 1905 by the Christian Brothers. In 1976, the Christian Brothers announced their intention to leave Fermoy. In 1980 with the closure of the secondary school, the Brothers left the town after 118 years. The school is still referred to as 'The Brothers'. The schools crest shows five steps representing the five years/classes through which the pupils advance in the school. The mitre represents the Catholic ethos of the school and also Bishop Timothy Murphy, who contributed so much to education in Fermoy (and to whom there is a statue erected).

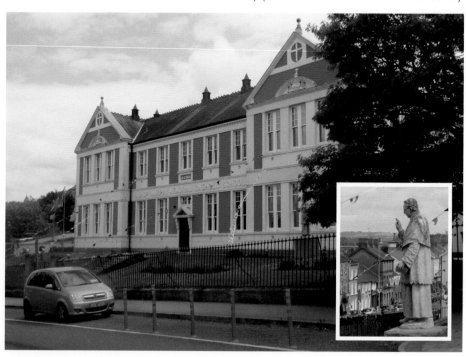

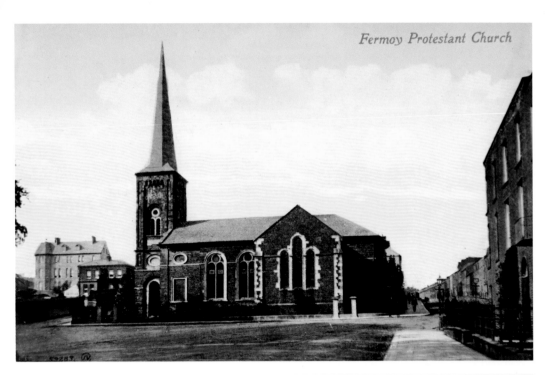

Fermoy Protestant Church

A Broad History

Christ Church, was designed by Abraham Hargrave the elder, and consecrated in 1809. The land on which it is sited was donated by the Baylor Family, whose descendants worship in Christ Church to this day. The majority of the building costs were paid by John Anderson, Founder of the town of Fermoy, and John Hyde of Castlehyde.

A broach spire and transepts in the Hiberno-Romanesque style were added in the late nineteenth century.

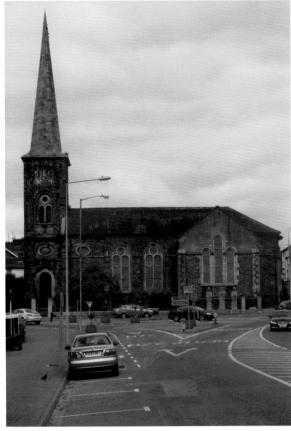

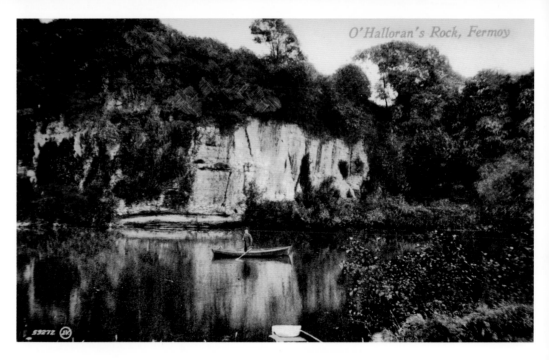

Cutting Through Rock

Located a few miles downstream from Fermoy, O'Halloran's Rock, named after a local landowner, remained as a recreational spot for many decades. The flow of the river is underlain by carboniferous limestone. It is hemmed in by ridges of Devonian sandstones and conglomerates, which can be seen in the old postcard.

Acknowledgements

We would like to express our gratitude to the Curator of Cork Public Museum, Stella Cherry, for her courtesy and encouragement towards this project. The old postcards within the book are archived in the Cork Public Museum. The present-day pictures were taken by the authors. We would like to thank Kieran Jordan and Sarah Henneberry of Moorepark for their insights and time. Much of the info was also distilled from the work of Colonel Grove White, Bill Power, and the *Stories Through Time* panels, which were developed by Avondhu Blackwater Partnership Limited, Ballyhoura Leader Project in association with Cork County Council. We would like to also thank the staff of Amberley Publishing for their vision with this work.

Cork Public Museum

The postcards shown in this book come from the archives of Cork Public Museum, which was first opened in 1910 and is the longest established local authority museum in Ireland. It is housed in a beautiful Georgian building set in the wonderfully landscaped Fitzgerald Park. During the turbulent pre-Second World War period, the building was utilised for a variety of civic and municipal functions that distracted from its museum role. Finally in 1945, the present incarnation of the Cork Public Museum was officially opened to the public and it has remained a museum ever since. In 2005 a contemporary and modern extension was added to the existing building making Cork Public Museum one of the most celebrated public buildings in Cork City. The collections of Cork Public Museum are as rich and as diverse as the history of the city itself. The ground floor of the museum has two permanent galleries, each dealing with the historical and archaeological heritage of Cork City and County. A visitor can trace the record from our earliest Mesolithic ancestors, to the civic leaders that brought the city into the twentieth century and beyond.

The museum displays some of the most important archaeological pieces known from Cork including Ireland's oldest pick and shovel, from a Bronze Age copper mine, the Iron Age Cork Helmet Horns, and the Garryduff Gold Bird, a marvel in early medieval craftsmanship. The archaeological section also takes the visitor into what life was like in medieval Cork where the finds from many recent excavations are exhibited, highlighting the importance of Cork as a trading and economic centre during medieval times. The historic displays focus on many important industrial, social and political aspects of Cork City's development since the eighteenth century. The visitor will see the ebb and flow of Cork's industrial past where butter making, glass manufacture, and silver working were once dominant but are now non-existence in modern Cork's industrial landscape. The civic exhibition enlivens us to the history of past Cork mayors and the legendary Lord Mayors like Tomás MacCurtain and Terence MacSwiney who both died in 1920 during the Irish War of Independence. The road to Irish independence is long and detailed and Cork Public Museum traces the roles played by many Cork people in achieving this aim from the eighteenth to the early twentieth century.

From amateur genealogists to university academics, Cork Public Museum proves invaluable to researchers and students alike. The museum houses a vast amount of artefacts and documents in its reserve collection. Though they may never be publically exhibited, they need to be protected and preserved so that future generations can have access to this material to aid further research and educate the future about our past. Cork Public Museum has served people from Cork and further afield since 1910 and its intent and desire is to continue as custodians of Cork's historical and archaeological legacy for the foreseeable future.

About the Authors

Kieran McCarthy

For over twenty years, Kieran has actively promoted Cork's heritage with its various communities and people. He has led and continues to lead successful heritage initiatives through his community talks, City and County school heritage programmes, walking tours, newspaper articles, books and his work through his heritage consultancy business. For the past sixteen years, Kieran has written a local heritage column in the *Cork Independent* on the history, geography and its intersection of modern-day life in communities in Cork City and County. He holds a PhD in Cultural Geography from University College Cork. He is the author of fourteen books: *Pathways Through Time, Historical Walking Trails of Cork City* (2001), *Cork: A Pictorial Journey* (co-written 2001), *Discover Cork* (2003), *A Dream Unfolding, Portrait of St Patrick's Hospital* (2004), *Voices of Cork: The Knitting Map Speaks* (2005), *In the Steps of St Finbarre, Voices and Memories of the Lee Valley* (2006), *Generations: Memories of the Lee Hydroelectric Scheme* (co-written, 2008), *Inheritance, Heritage and Memory in the Lee Valley, Co. Cork* (2010), *Royal Cork Institution, Pioneer of Education* (2010), and *Munster Agricultural Society, The Story of the Cork Showgrounds* (2010), *Cork City Through Time* (co-written, 2012), *Journeys of Faith, Our Lady of Lourdes Church Ballinlough, Celebrating 75 Years* (2013), *West Cork Through Time* (co-written, 2013) and *Cork Harbour Through Time* (co-written, 2014). In June 2009 and May 2014, Kieran was elected as a local government councillor (Independent) to Cork City Council. He is also a member of the EU's Committee of the Regions. More on Kieran's work can be seen at www.corkheritage.ie and www.kieranmccarthy.ie.

Daniel Breen

Daniel Breen was born in Ballincollig, Co Cork in 1979. Having graduated with a degree in history and archaeology from University College Cork in 2001, he achieved an MA from Sheffield University in European Historical Archaeology in 2002. While at college, Daniel spent his summer months working on various archaeological sites throughout Ireland. Since graduation, he has worked in the Cork Public Museum where he now holds the position of Assistant Curator. He co-wrote *Cork City Through Time* with Kieran McCarthy (2012), *West Cork Through Time* (2013) & *Cork Harbour Through Time* (2014). In 2014 he co-authored *The Cork International Exhibition 1902-1903 – Snapshot of Edwardian Cork* with Tom Spalding, published by Irish Academic Press.